BRITAIN IN OLD PH(

SUTTON-IN-ASHFIELD

From the W.H. Pickard Collection

J. BARRIE SMITH

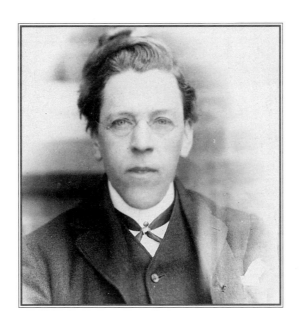

SUTTON PUBLISHING LIMITED

Sutton Publishing Limited
Phoenix Mill · Thrupp · Stroud
Gloucestershire · GL5 2BU

First published 1996

Cover photographs. *front*: W.H. Pickard's
brother-in-law and a friend; *back*: horse-drawn
wagonette with W.H. Pickard's nephew.

British Library Cataloguing in Publication Data
A catalogue record for this book is available from the
British Library.

ISBN 0-7509-1373-8

Typeset in 10/12 Perpetua.
Typesetting and origination by
Sutton Publishing Limited.
Printed in Great Britain by
Ebenezer Baylis, Worcester.

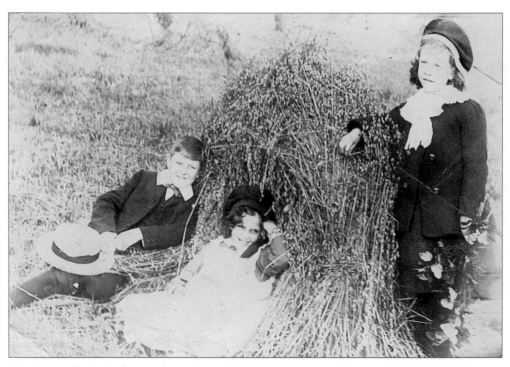

The photographer's daughters and a nephew in the corn.

CONTENTS

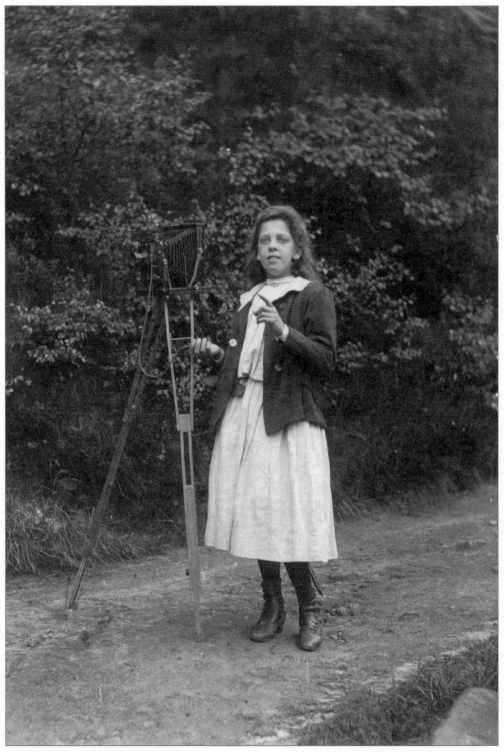

William Henry and Eleanor Pickard had two daughters, besides one who died in infancy. The younger of the two, Annie, the author's mother, is seen here, posing with one of her father's cameras.

INTRODUCTION

In the early years of this century my maternal grandfather, Harry Pickard (as he was known to his friends), must have been a well-known figure as he tramped around Sutton-in-Ashfield and the surrounding area with his heavy tripod on his shoulder and carrying his large camera and photographic equipment.

His collection of local photographs is a real treasure and forms quite a comprehensive study of Sutton-in-Ashfield and district in Edwardian times. Although local photographs of this era are not uncommon, many of the pictures in this collection are given added interest by personal touches such as the inclusion of family and friends in the views, so that contemporary fashions and illustrations of a bygone way of life give atmosphere to the pictures.

Although few exact dates are ascertainable for the pictures, it is almost certain that they are all within or slightly after the reign of Edward VII. The ages of the people on some of the photographs is a fair guide and also the fact that my grandfather was an invalid for a considerable time before he died in 1925.

This collection of his photographs narrowly escaped destruction in about 1938 when, following the death of my grandmother, his photographic equipment was disposed of as being of no interest. Boxes of glass negatives were smashed, but fortunately my mother kept about 300 prints of which this is a selection.

Wishing to put these prints into a more permanent form which others might have the opportunity of enjoying, I dedicate this book to the memory of the photographer, William Henry Pickard.

J. Barrie Smith

AUTHOR'S NOTE

A few of W.H. Pickard's photographs may have been seen elsewhere, but those reproduced here are from originals printed by the photographer himself.

In 1907 Luther Lindley published a *History of Sutton-in-Ashfield* which, in addition to historical information, tells us much about contemporary Sutton. The author has drawn much information from this source. For the rest he has relied on his memory of information supplied by his parents.

THE
PHOTOGRAPHER

William Henry Pickard was born in Sutton-in-Ashfield, Nottinghamshire, on 3 August 1860. He was the eighth of the fifteen children of John Pickard and his wife Mary Ann (née Haynes), although only eight of the children survived beyond infancy.

In about the middle of the nineteenth century Sutton-in-Ashfield was developing as a centre of the textile trade as the manufacture of hosiery was changing from a cottage industry with the building of factories. John Pickard's father had come from Leicester and the whole family seems to have been involved in this industry. Eventually John Pickard established a factory on Cursham Street and several of his sons assisted in the business, William Henry being in charge of the despatch department. The business closed in the 1920s and the factory was later demolished without trace — unfortunately (to the best of my knowledge) without any photographic record of the exterior of the building.

William Henry married Eleanor Bown, a member of another well-known Sutton family. They lived, at various times, on King Street and in a cottage behind Aked's shop and finally, in 1894, they built a house called Alpha Cottage (now no. 44), Kirkby Road, near Spring Bank. There they lived for the rest of their lives. William Henry died in 1925, following a stroke, and his widow survived him by thirteen years.

W.H. Pickard was a keen photographer at a time when photography was a hobby that was not followed by many people. He had at least two large cameras on tripods (make unknown). One or two photographs have survived which feature one of these cameras (presumably photographed by the other). He developed and printed his own pictures in an improvised darkroom converted from a lean-to shed at the back of the house.

THE PHOTOGRAPHER
& HIS FAMILY

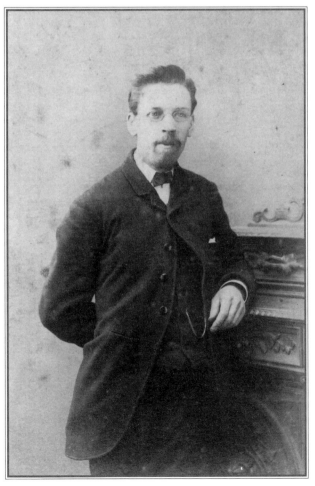

William Henry Pickard.

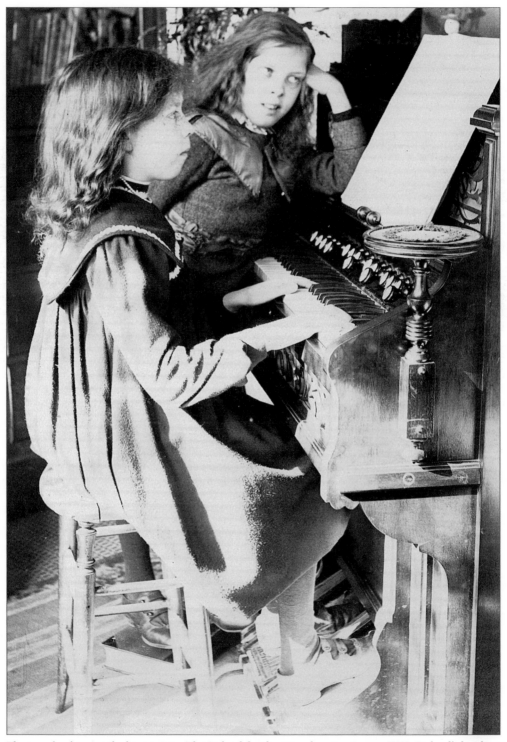

The two daughters at the harmonium. The Pickard family enjoyed music. Among W.H. Pickard's brothers and sisters was a church organist and several who were quite accomplished pianists and singers. From an early age Janet and Annie were taught by their father to play the harmonium in the front room of their home.

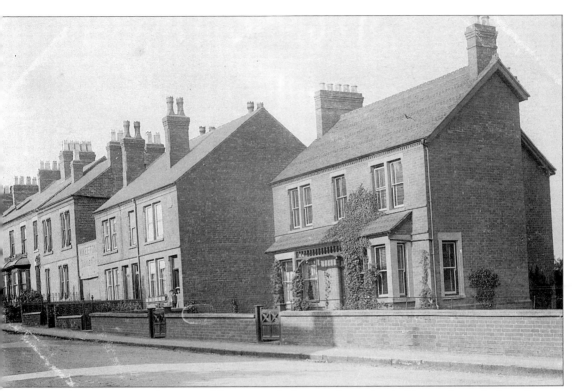

Alpha Cottage appears in the centre of this picture, the first set of semi-detached houses. It was the first of the houses built at the bottom of Kirkby Road, hence its name. My grandfather bought the plot of land at an auction on 9 March 1894; on 22 June the same year he signed an agreement with the builder, James Evans, to pay £142 16s on condition the house was 'complete and finished and ready for occupation' on 28 August of the same year! The land was part of an area called 'The Weeds' and, as plots were being sold for building, John and Adah Dove (my grandfather's brother-in-law and sister) built a house attached to Alpha Cottage, called Beta Cottage.

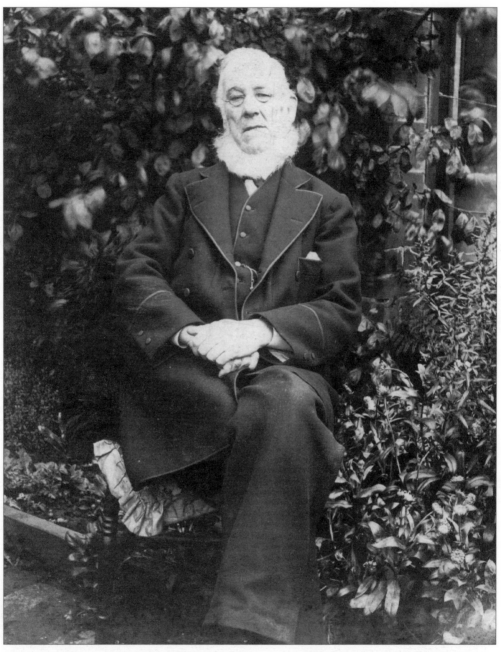

John Pickard, my great-grandfather. This photograph was taken by his son in the garden at Alpha Cottage. Photographs show him to have been a tall and distinguished figure. He lived at the house adjoining his factory on Cursham Street. He was very much a family man with eight surviving children and over twenty grandchildren. My mother used to tell of her childhood memories of the Christmas parties held for the whole family at the factory. John Pickard was not only very much involved in the work of Sutton Urban District Council, but he was also a County Councillor. Throughout his life he had been closely connected with the Primitive Methodist Church and for many years he was a leader and Sunday school superintendent at the chapel on Reform Street. In his declining years, following the death of his wife, he was cared for by his only unmarried daughter, Sarah.

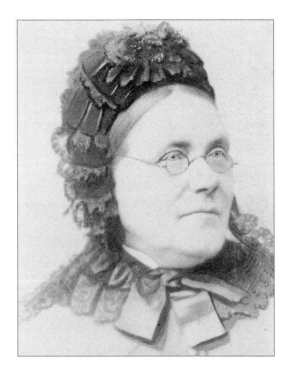

John Pickard married Mary Ann Haynes. She died in 1902 at the age of seventy-four, predeceasing her husband by thirteen years. This is a typical photograph of her with bonnet and glasses.

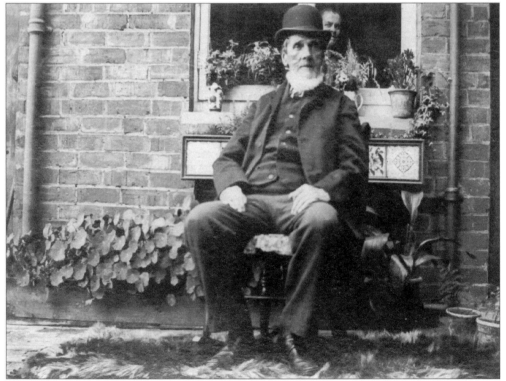

John Bown was the photographer's father-in-law. W.H. Pickard took this photograph in the backyard of Alpha Cottage. Eleanor is at the kitchen window, unaware that she is on the photograph. Notice the rug and the aspidistra brought out for the occasion.

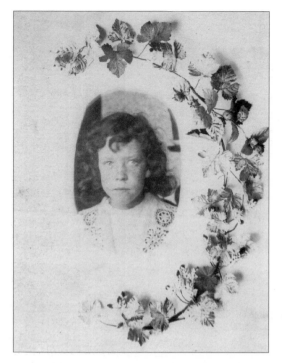

William Henry's elder daughter, Janet. This picture is included to show the style of 'vignette' portraits. Having taken the photograph he would take a print from it, framed in flowers from the garden or fields. Before being placed in 'fixing solution', the photograph, on 'daylight paper', would be placed in a glass frame and exposed to the light until the picture appeared.

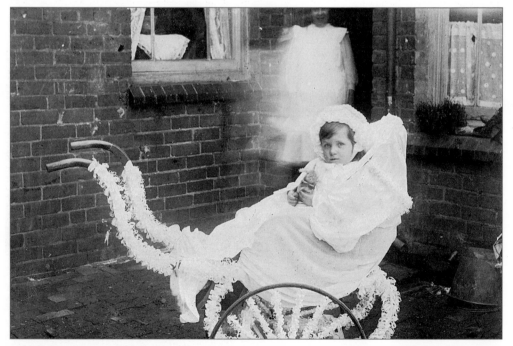

Dorothy Brailsford, W.H. Pickard's sister's daughter. Two points of interest in this picture are the style of the pram (with two wheels and a stand so that it would not tip up when stationary, see page 73, bottom photograph) and the fact that the pram is decorated. The age of the child would indicate that it is about the time of the coronation in 1911 and the pram may well have been decorated for this occasion.

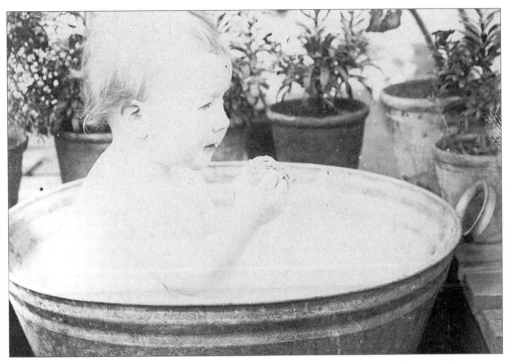

Arthur Dove, the photographer's sister's son. The family lived next door at Beta Cottage and it appears that little Arthur is having his bath in the greenhouse at the bottom of the garden. The author well remembers this greenhouse where Arthur's father, John Dove, a miner, eked out a living for the family by growing tomatoes, lettuces, cucumbers, etc. His wife would sell these at the front of the house.

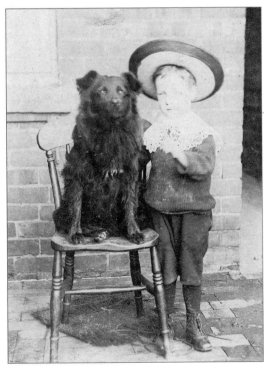

Arthur Dove again, a little older. Here he is in the yard at Alpha Cottage posing with my mother's dog, Laddie.

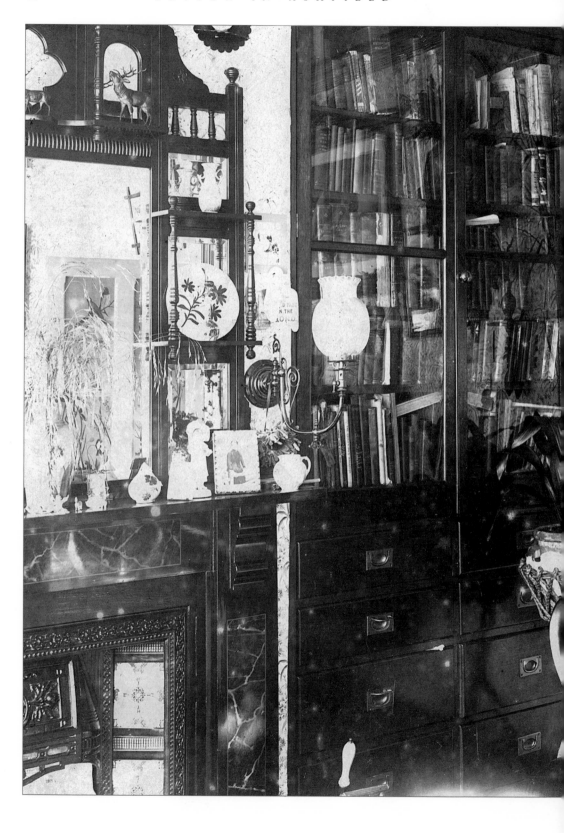

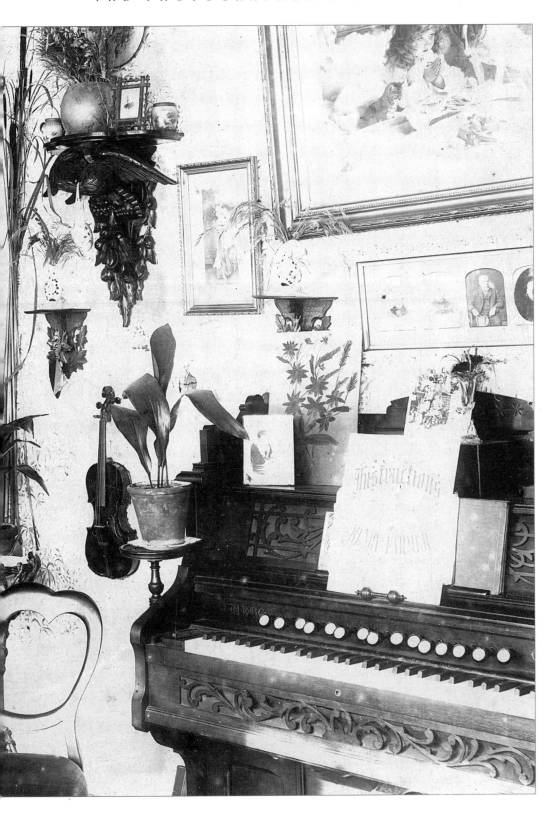

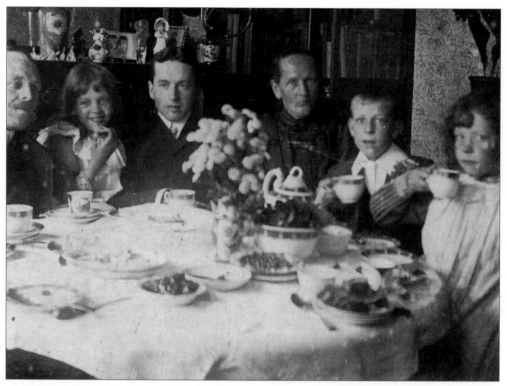

A tea party in the front room at Alpha Cottage. Notice the ornate china teapot and the vase of flowers on the table. This 'best' tea service was still being used by my parents as recently as the 1950s. Seated at the round table with my mother (second left) and her sister (far right) are her Uncle Enoch and Aunt Emma Wilson and their young son, John William. They lived on West End and their son, always called by both Christian names, became the commissionaire at the King's Cinema. The young man to the left of Aunt Emma was a Mr Welsh, who lodged with the family.

Previous pages: The front room at Alpha Cottage, the photographer's home on Kirkby Road. The author remembers the room being virtually unchanged right up to the death of his grandmother in 1938. On the left is the iron-framed fireplace set with ceramic tiles, surmounted by an overmantle, ornate with shelves, ornament-filled niches, vases and photographs. On either side was a wall-fitted gas lamp, one of which is visible here. Through the mirror can be seen the door into the back room and on the panels were hand-painted flowers. Part of the polished brass fire-irons can be seen just to the right of the fireplace. The chimney-corner is filled with a glass-fronted built-in bookcase with drawers below, in front of which is the typical aspidistra on a stand and in front of that a chair with a black horsehair seat. On the right is the harmonium with a violin on the wall beside it. The wall is covered with bracket shelves for even more ornaments and flower arrangements and in the corner a spray of dried bulrushes decorates what little space is left. The large picture above the family photographs is a print that was popular at the time. It is a painting by C. Burton Barber called *Suspense* and has often been reproduced in recent times.

A WALK AROUND SUTTON

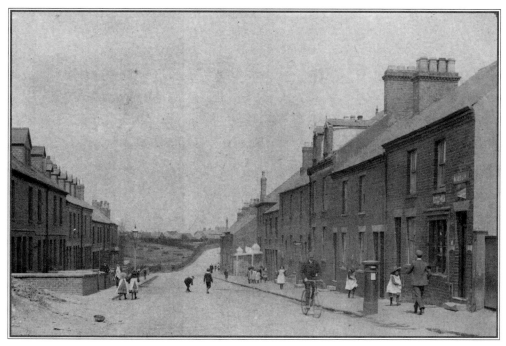

Kirkby Road, looking down the hill towards Spring Bank. This photograph was taken before the council houses were built on Spring Bank and also before the traffic island was made (just before the Second World War). On the right of the picture is Clifton's butcher's shop, owned by several generations of the family and outside which is a Victorian pillar-box. Alpha Cottage is on the left, at the bottom of the hill.

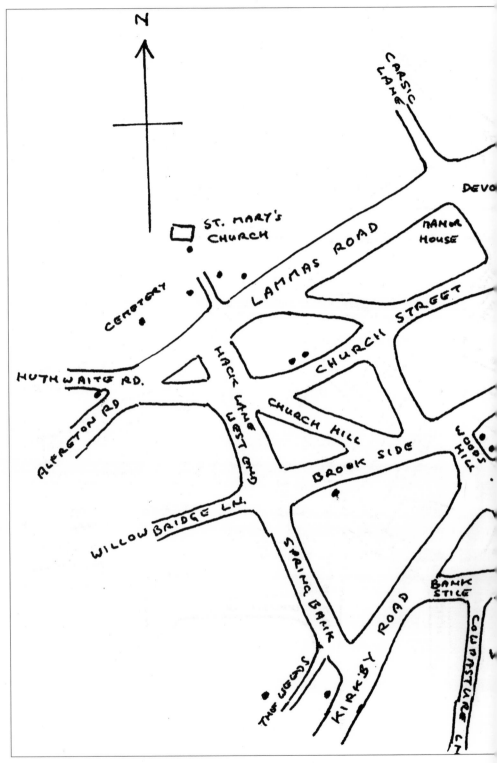

Sketch-map of Sutton town centre.

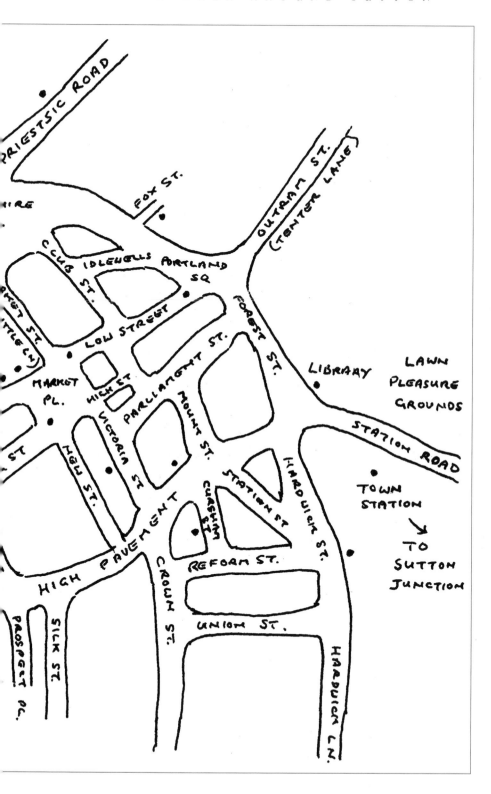

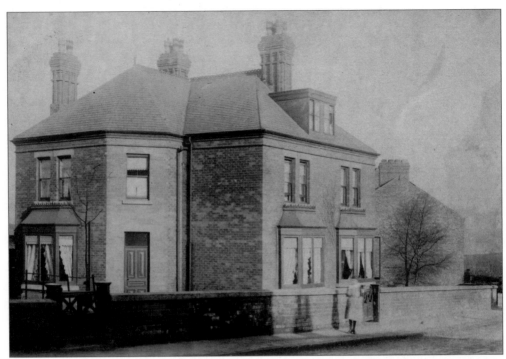

This pair of large semi-detached houses stands on Spring Bank. For many years the one on the right was the Congregational Manse, occupied by the Revd J.T. Jones until his retirement and return to his native Wales.

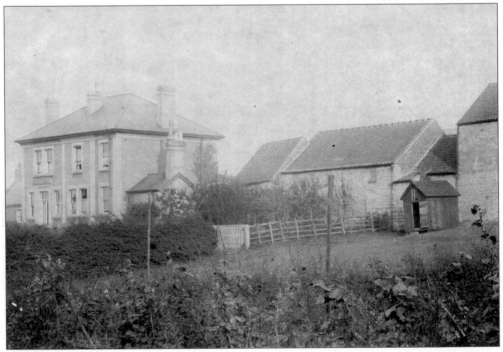

Spring Bank House, owned by Mr and Mrs J. Craster Sampson, stands on the part of Kirkby Road beyond Spring Bank where it adjoins Woods Hill. It was built in 1895.

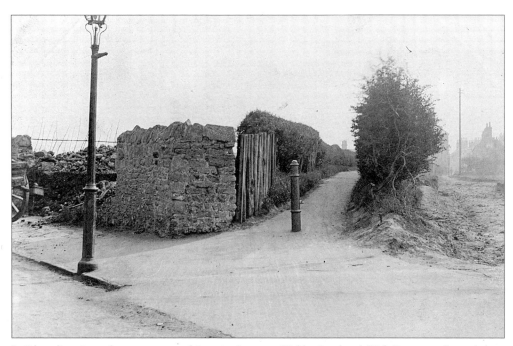

In Edwardian times there was no road junction between Kirkby Road and High Pavement. Instead there was a narrow footpath linking Kirkby Road to the junction of High Pavement and Cowpasture Lane. This footpath had an iron bollard at each end and was called Bank Stile, a name which is perpetuated as a house name at the end of Cowpasture Lane. The above photograph shows this footpath looking towards High Pavement and the one below is looking towards Kirkby road.

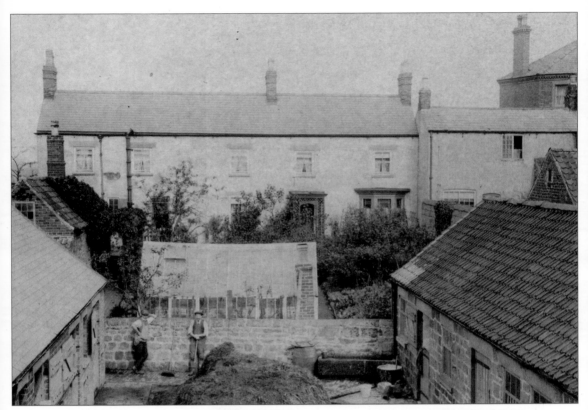

Cowpasture Farm stands at the junction of High Pavement and Cowpasture Lane. For many years it was owned by the Deakin family. Abraham ('Abe') Deakin and his two sons, Douglas and Geoffrey, had a milk round using a horse-drawn two-wheeled cart. One wonders where this photograph was taken. Could it possibly be from the top of the windmill, the shell of which can still be seen from Cowpasture Lane.

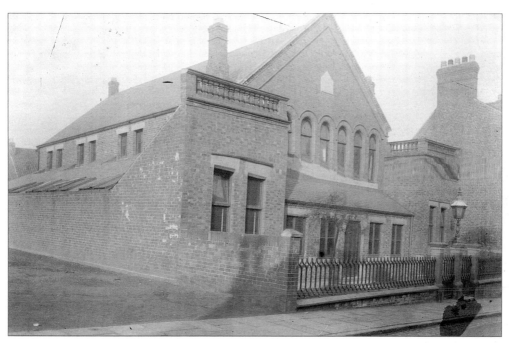

Most of Victoria Street was demolished when the Sutton Centre complex was constructed. This picture shows the Congregational Sunday School Hall. It was replaced by a multi-functional building attached to the church at the top of Victoria Street.

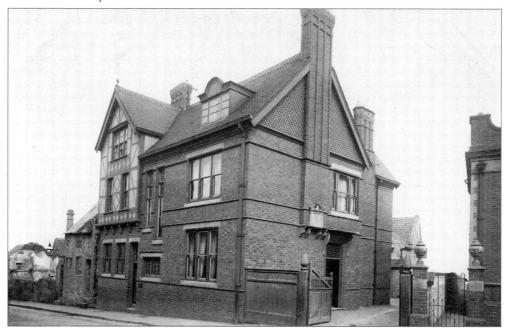

As we continue along High Pavement to the junction with Forest Street we come to the site of Dr Tweedie's house, called Maunside. It stood next to the Victoria Free Library. After Dr Tweedie's departure the building was used by the Sutton-in-Ashfield Urban District Council Health Department and later the Housing Department until the 1970s. The building was subsequently demolished and the present Kwiksave store was built on the site.

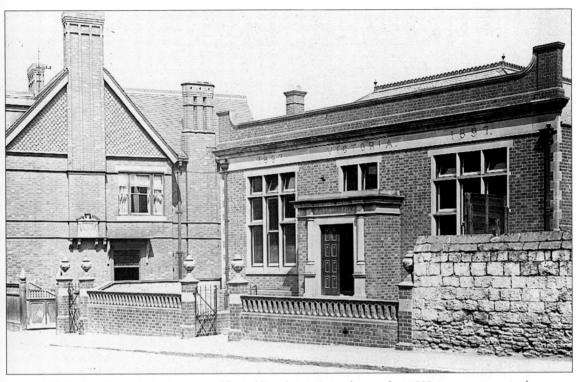

The Victoria Free Library was erected by public subscription and opened in 1899 to commemorate the diamond jubilee of Queen Victoria. It was situated on Forest Street opposite the end of High Pavement and was demolished following the building of the Idlewells complex, which provided far more spacious accommodation for the library.

SUTTON-IN-ASHFIELD.

... Programme

OF THE

OFFICIAL OPENING

OF THE

ictoria ree ibrary

BY THEIR GRACES THE

DUKE AND DUCHESS OF PORTLAND,

ON WEDNESDAY, MAY 3rd, 1899, AT 3 O'CLOCK.

The Library has been erected by Public Subscription to commemorate the Diamond Jubilee of the long and glorious reign of Her Most Gracious Majesty, Queen Victoria.

CHAIRMAN - - MR. JOHN CRASTER SAMPSON.

1. Three o'clock. Arrival of the Duke and Duchess of Portland.
2. The Chairman will meet Their Graces at the Entrance Gate, present a Gold Key to His Grace the Duke, and ask the Duke and Duchess of Portland to open and inspect the Free Library Buildings.
 The Committee will accompany the Chairman at this Inspection.
3. After the Inspection the proceedings will take place in a Marquee in the rear of the Library.
4. The Chairman will introduce
 Miss Norah Kitchen, Miss Maggie Nesbitt, and Miss Flo Adlington to the Duchess of Portland, when the former will ask Her Grace to accept a Bouquet.
5 The Chairman will ask
 The Duke of Portland to declare the Free Library open.
6. Speech of His Grace the Duke of Portland.
7. Her Grace the Duchess of Portland will, on behalf of the Subscribers, present to the Chairman of the Urban District Council as representing the Town, the Library erected by Public Subscription.
8. Dr. Nesbitt, J.P., will propose,
9. Mr. A. H. Bonser, C.C., will second
 A Vote of Thanks to the Duke and Duchess of Portland for their attendance and generosity.
10. Reply.
11. Mr. J. D. Fidler, Clerk to the Urban Authority, will propose
12. Mr. Fisher will second
 A Vote of Thanks to the Chairman for presiding, and for his valuable help as Chairman of the Library.Committee.
13. Reply.
14. "God Save the Queen."

F. W. BUCK AND SONS, TYP., SUTTON.

The programme of the official opening of the Victoria Free Library, 3 May 1899.

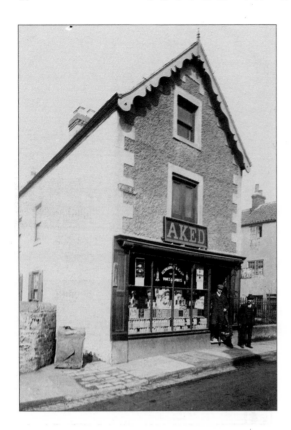

Aked's shop was a small grocery business, the first building on the left as one entered King Street from Kirby Road.

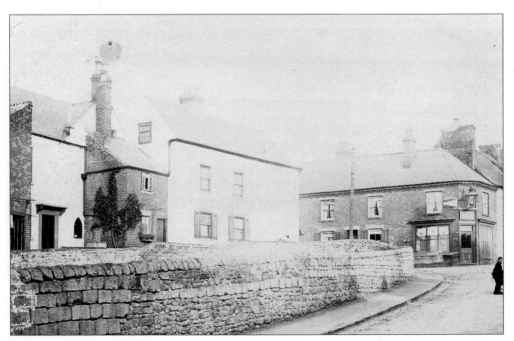

Behind Aked's shop was this yard containing several small cottages which faced Wood's Hill. It was in one of these that the author's mother was born.

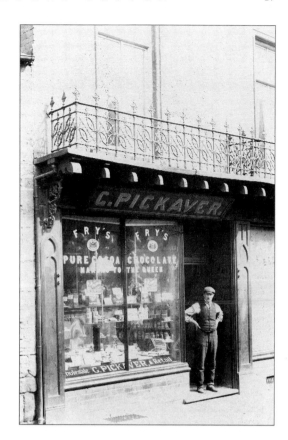

Continuing along King Street towards the market-place, on the left side one came to Pickaver's shop, another small family business.

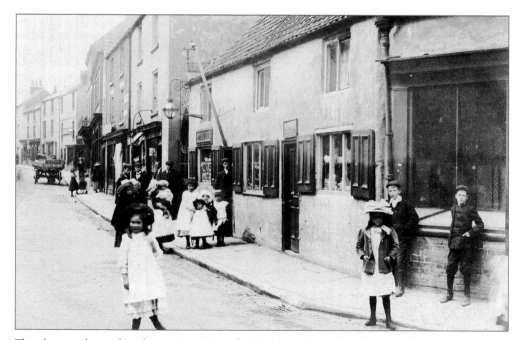

This photograph was also taken on King Street, looking from the market-place end of the street.

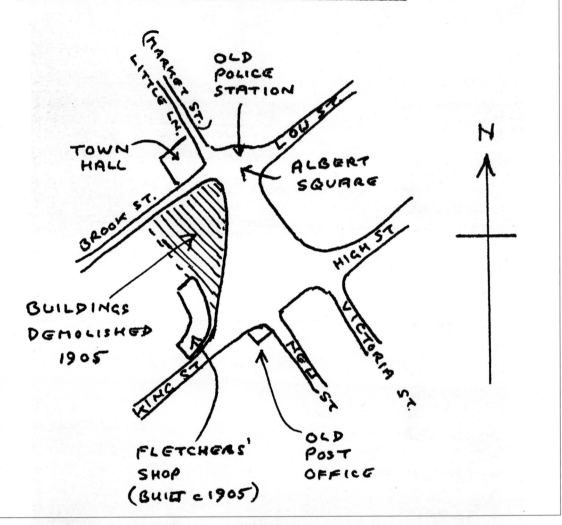

SKETCH-MAP OF SUTTON MARKET-PLACE
SHOWING ALTERATIONS OF 1905

Originally the market-place at Sutton was triangular in shape, but in 1905 there was much redevelopment in the centre of the town. This involved the demolition of buildings on one side of the market-place, thus enlarging it into a square, as shown in this sketch-map.

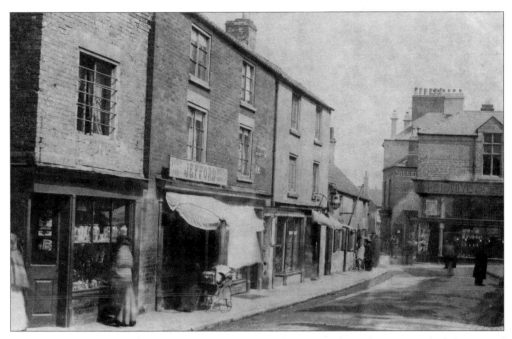

This picture is taken from King Street, looking towards the market-place, showing, on the left, some of the old shops which were demolished when the market was redeveloped.

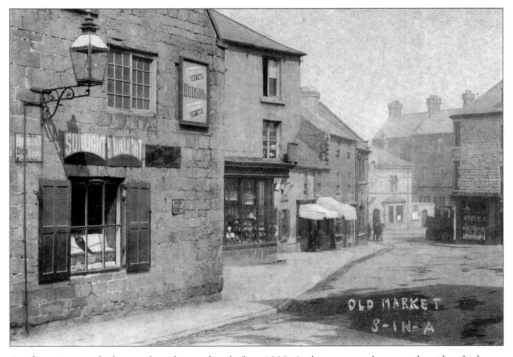

Another picture which must have been taken before 1905. It shows more shops on the side which was demolished.

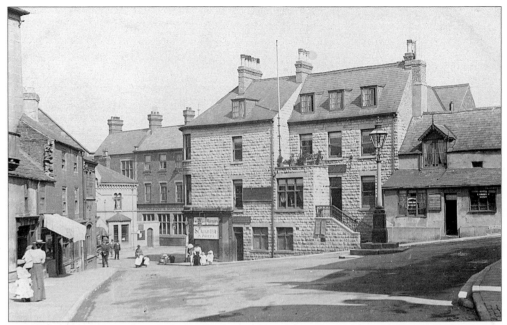

From the King Street entrance to the market we look down the slope towards the entrance to Low Street where there was an open area called Albert Square. On one side of this was the old police station which can be seen quite clearly facing up the market. This was replaced by a purpose-built building on Brook Street, and when its size became inadequate a new police station was built on Church Street. In the centre of the picture is the Denman's Head Hotel.

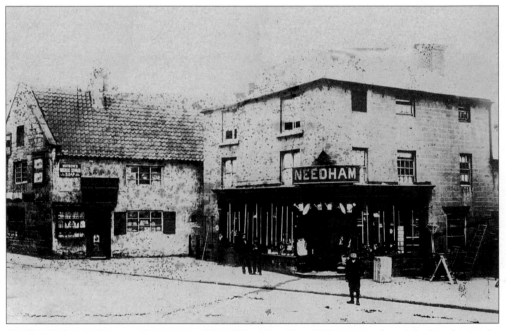

Needham's shop is shown in this picture of the old market-place. When it was demolished, owing to the redevelopment in 1905, they moved into a new shop at the bottom of the market. The Needhams were members of a well-known Sutton family and they had an ironmongery business.

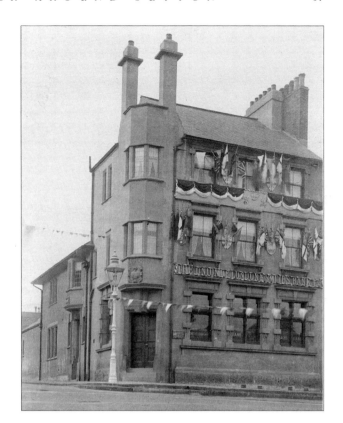

This view of the top of the market shows the bank on the corner of Victoria Street. This picture can be dated with some accuracy as the building is decorated for the coronation in 1911.

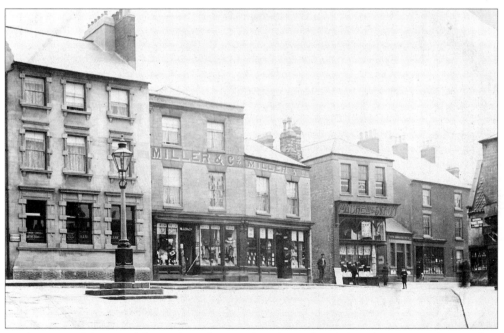

Another view of the top of the market. This must have been taken before the previous photograph as some of the buildings demolished in 1905 can be seen at the right-hand side.

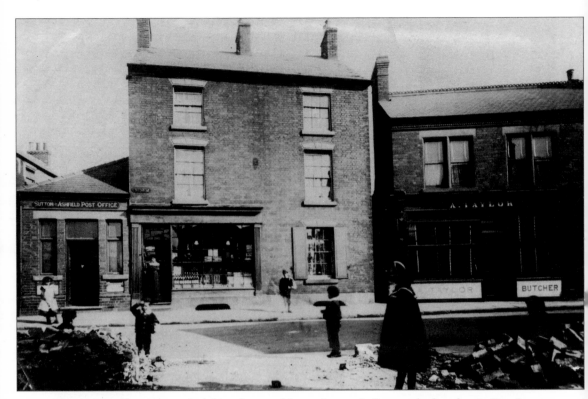

The old post office (seen on the left) at the top of the market was built on to the first shop in King Street. Later, the two were incorporated into one shop – Shepperson's cycle dealers. The post office moved on to Brook Street into a new building, more recently into another new building on the opposite side, then into the Co-operative building on Portland Square and most recently into Asda. The girl in the foreground of this photograph is one of the photographer's daughters. She is standing by a pile of rubble which is probably from the demolition work of 1905. As she surveyed the remains of the demolished buildings my mother could have had no idea that a few years later, when she left school, she would be working in a building on the same site. She was apprenticed as a milliner at Fletcher Brothers, whose shops occupied the new corner of King Street and the market-place (see page 33).

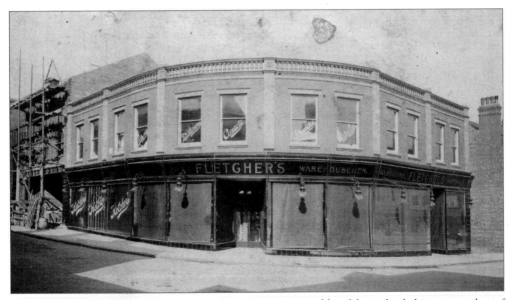

When Fletcher's business was wound up, the premises were sold and later divided into a number of smaller shops.

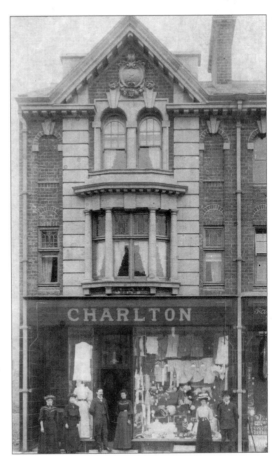

Charlton's was one of the shops on Brook Street, at the bottom of the altered market-place. The shop is still there but has not been Charlton's for many years.

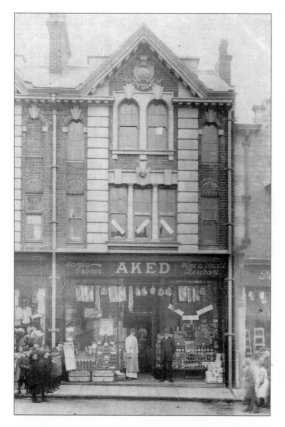

Aked's family grocers' shop at the bottom of the market was a flourishing business owned by a well-known Sutton family. Mr John Aked lived in a large house on Kirkby Road near the entrance to King Street.

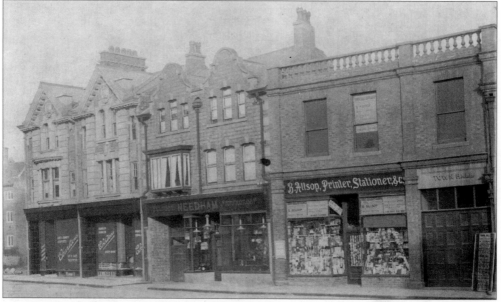

Continuing along the bottom of the market towards Low Street the entrance to the town hall is reached — not a very imposing entrance for this hall, which is actually above the shops. It was never an administrative centre, but a public hall that could be hired for functions.

In this picture can be seen the top of the town hall above the buildings in the foreground which were demolished in the 1905 redevelopment. The town hall was built in 1888, but the tower with the proposed clock was never completed.

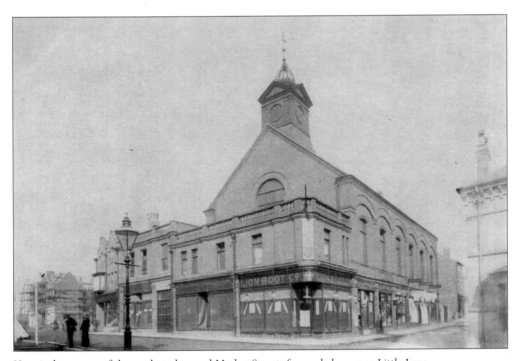

Here is the corner of the market-place and Market Street, formerly known as Little Lane.

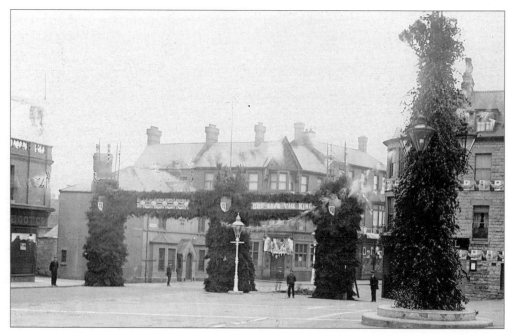

These two pictures of the market-place were taken in 1911 and the decorations were to celebrate the coronation of King George V and Queen Mary on 22 June. My mother informed me that shortly after her father took these pictures the decorations were blown down by the wind and were not replaced, so it is likely that these are the only pictures taken of that occasion.

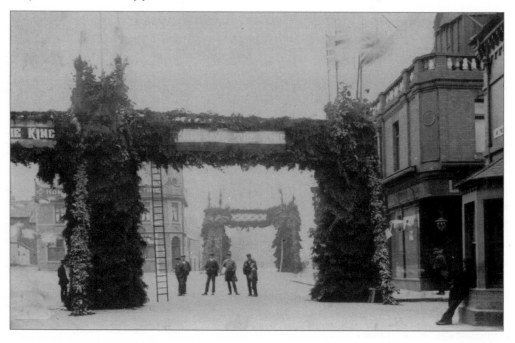

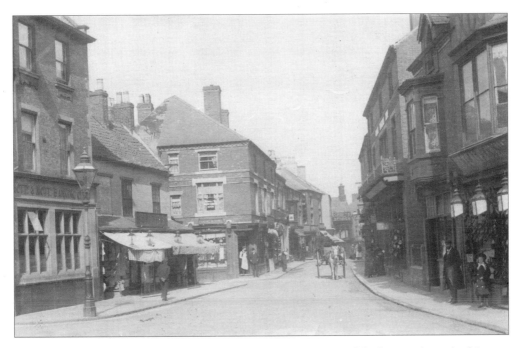

From the market-place we move along Low Street. The above photograph looks towards Portland Square. The view below looks from Portland Square back in the direction of the market. When these pictures were taken the only traffic was a horse and cart and people stood about in the middle of the road. In later years Low Street became a busy thoroughfare, but it is a pedestrianized area now.

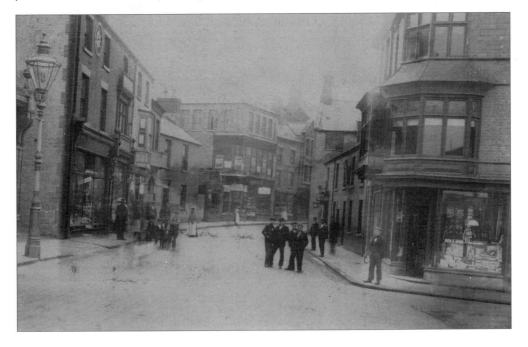

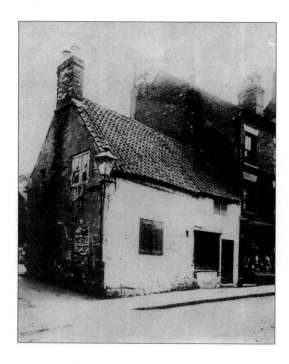

This building, dating from the 1700s, was Miss Lee's shop on Low Street. It was replaced by G.J. Hepworth's outfitters' shop.

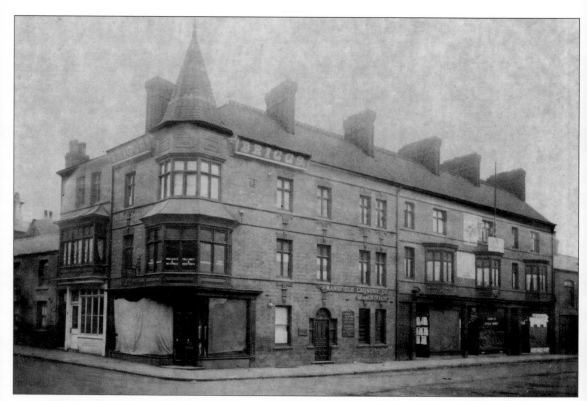

This picture shows the corner of Low Street and Portland Square with the chemist's shop owned by Mr Briggs. The buidling still bears the inscription 'JB 1892'.

The Conservative Club on Fox Street (off Portland Square) remains virtually unchanged. The foundation stone was laid by Colonel A.U. Heathcote RE on 12 July 1904.

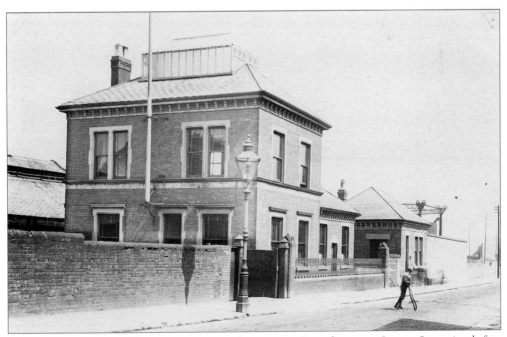

In my grandfather's time the offices for Sutton Urban District Council were on Outram Street, just before the Great Northern Railway station.

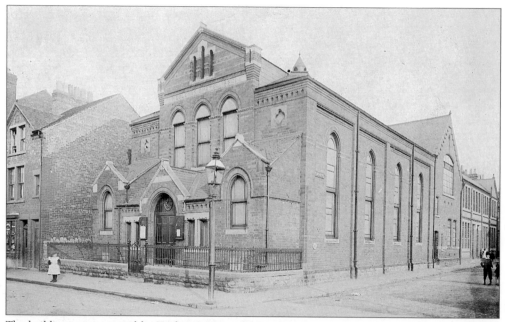

The building now occupied by Trading Post on the corner of Outram Street and Welbeck Street was originally the Wesleyan Methodist Chapel. It was built in 1883 when the chapel on Low Street closed. In 1965 the Methodists on Outram Street united with those meeting on Brook Street and eventually moved to the expanded premises on Brook Street, called St John's Church, which opened in 1973.

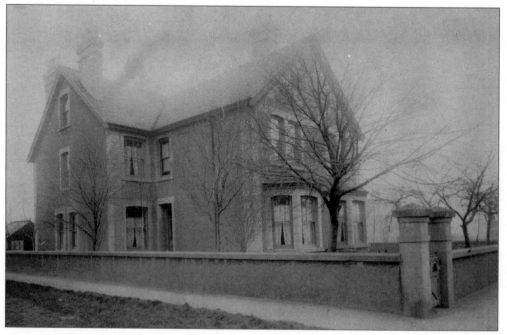

This house on Priestsic Road looks very much the same today. It was occupied by someone named Law.

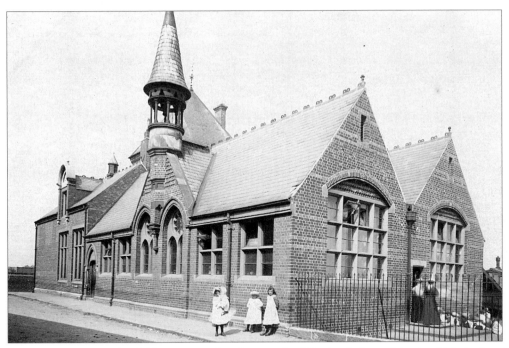

My mother is among the children seen in this photograph of Hardwick Street School, which she later attended. It was later called the Croft School, transferring to the present building on Station Road. The school on Hardwick Street has now been demolished.

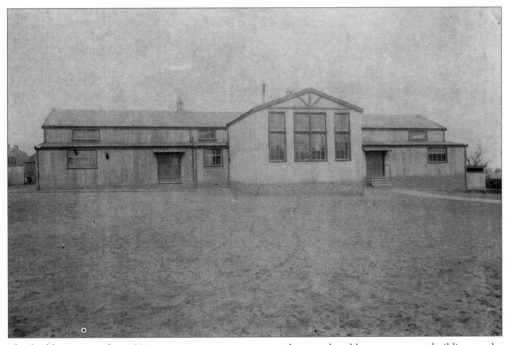

This building, erected in 1906, was a temporary structure, later replaced by a permanent building on the same site. It was the Higher Standard School on Station Road, the headmaster being Mr William Collins BA. The photographer's younger daughter was a pupil at this school.

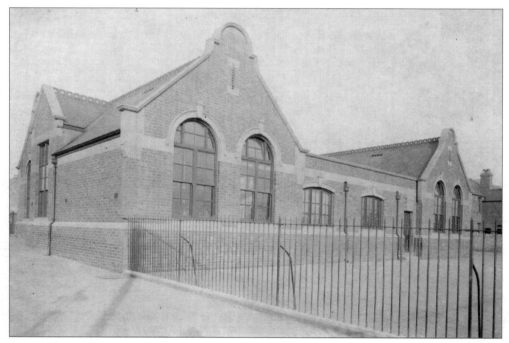

The Central School, as it was called, on Priestsic Road, is still in use as a primary school. W.H. Pickard's brother-in-law, Joseph Henry Brailsford, was at one time headmaster. The school was opened in 1900.

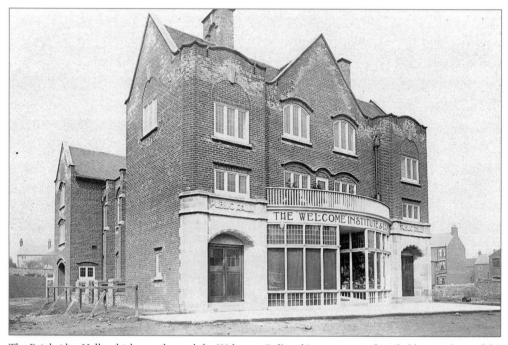

The Bainbridge Hall, which once housed the Welcome Café and Institute, was founded by members of the Free Churches of the town to provide a temperance social club. It contains a hall on the first floor and bowling green at the rear.

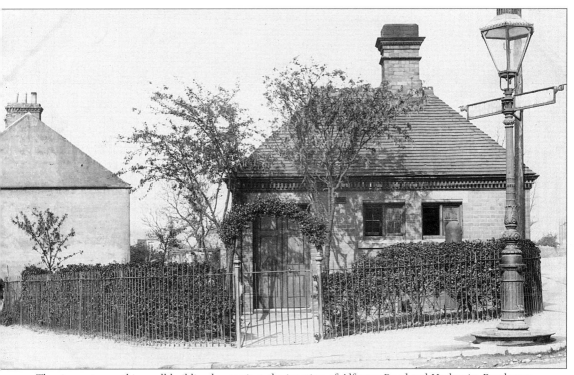

The signpost near this small building locates it at the junction of Alfreton Road and Huthwaite Road near the cemetery. It was apparently a pumping station, presumably for increasing the pressure along the water mains.

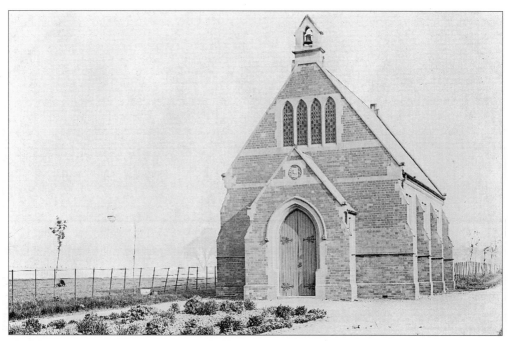

The cemetery chapel fell into disuse and was demolished some years ago. The war memorial, of course, had not been erected as this picture was taken some years before the First World War. The cemetery has now been greatly extended.

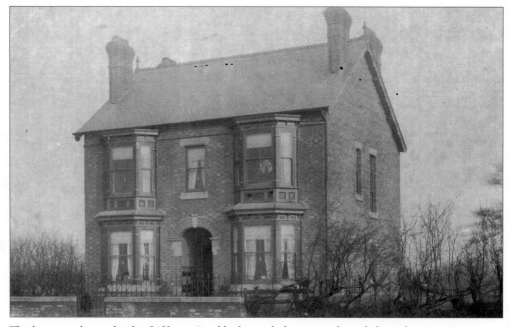

This house on the south side of Alfreton Road looks much the same today. It belonged to Miss Straw.

Two more views of Alfreton Road from the north side. In the above photograph Jackson's shop can just be distinguished between the houses. As the population of Sutton grew, the town expanded along the main access roads. Desirable residences were built, such as these large semi-detached houses which look much the same ninety years later.

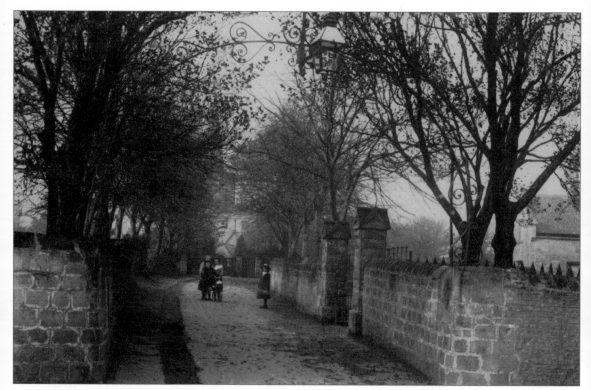

St Mary's Church, viewed from Hack Lane. In the photograph are the author's mother and other members of the family. In the foreground can be seen an archway supporting a gas lamp. On the right is the entrance to the school house.

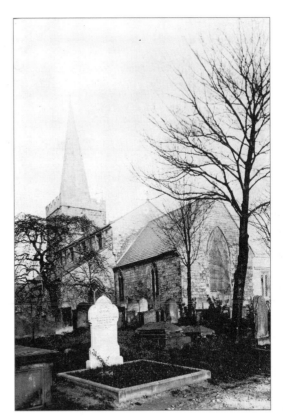

Two photographs of the church viewed from
the south-east.

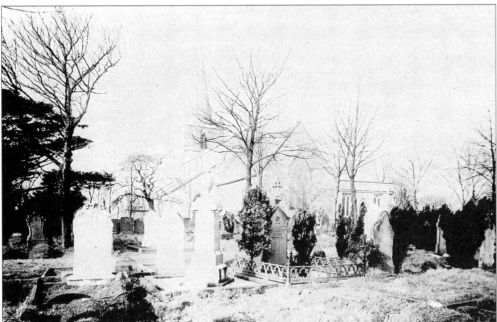

Gravestones of the period, *c.* 1910, were often large and ornate, made of huge slabs of marble, granite or
slate. Sometimes there was a kerb or fence around the grave. Many of these stones have now fallen or
been broken and the inscriptions are often illegible.

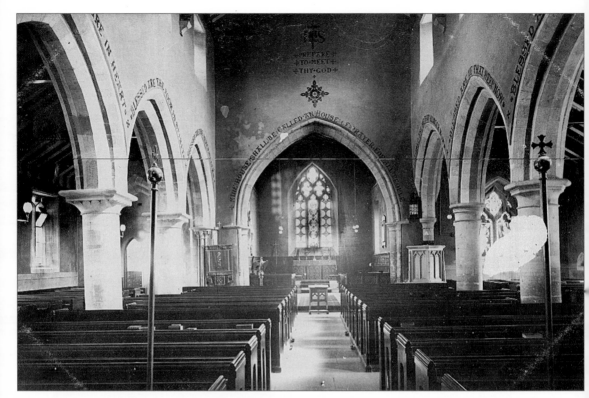

Interior of St Mary's Church, looking towards the east. The author's mother remembered that her father set up his camera and left the shutter open while he went to have his tea as the dark interior required a long exposure – there were no fast films and flash photographs in those days! He returned in a thunderstorm.

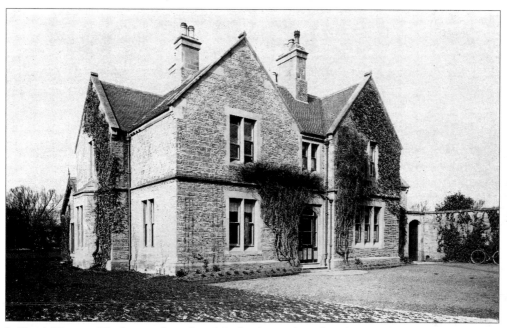

St Mary's Vicarage. This has now been demolished and a number of residences and the Magdalene Centre have been built on the land.

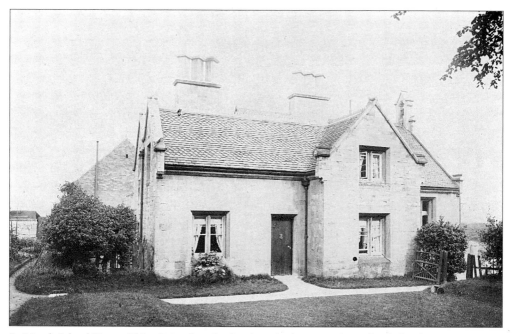

St Mary's School House. This adjoins the school and was built as a residence for the headmaster.

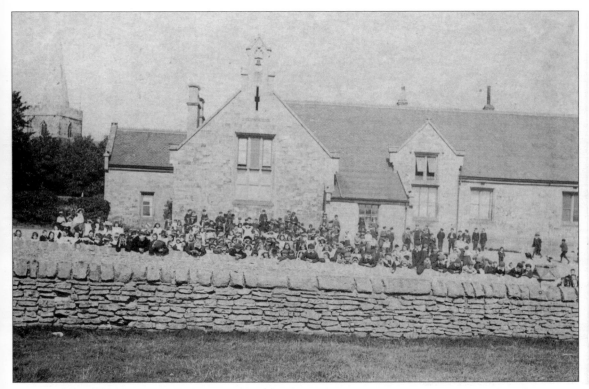

St Mary's Church of England School, formerly the National School built in 1845, is now an independent school called the Lammas School. In 1907 Lindley records (see p. 6) that there was accommodation for 400 children.

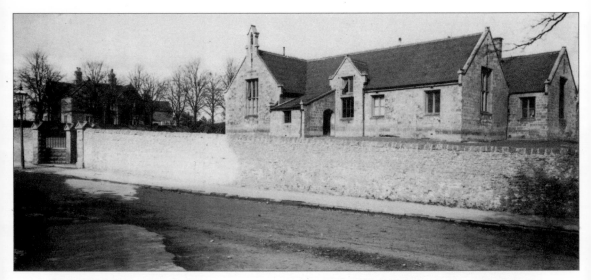

This second photograph of St Mary's C. of E. School was taken at a later date. This is indicated by the pavement in front of the wall – the photograph above shows a grass verge. Those who know the school today will see that the entrance has been moved.

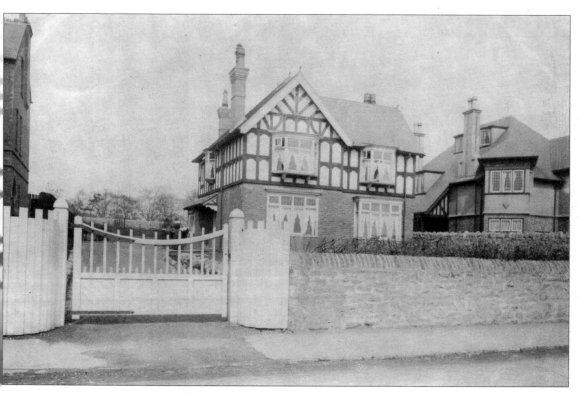

Kirkstede, a house on Church Street that was once the home of George Gershom Bonser (d. 1947), an eminent Suttonian, writer and local historian who served for many years on the Urban District Council and St Mary's Parish Council.

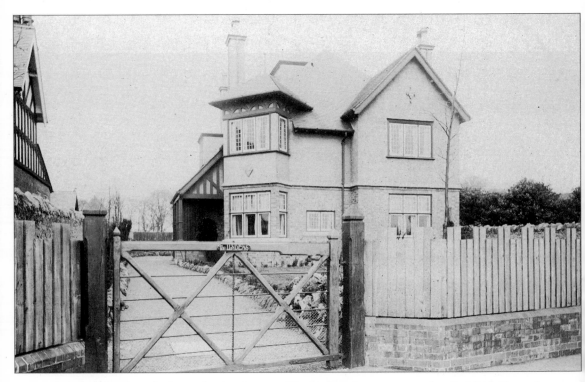

Next to Kirkstede is this house, bearing the name The Lindens, but more recently called Bank House. In 1987 it became Bank House Residential Home for the elderly.

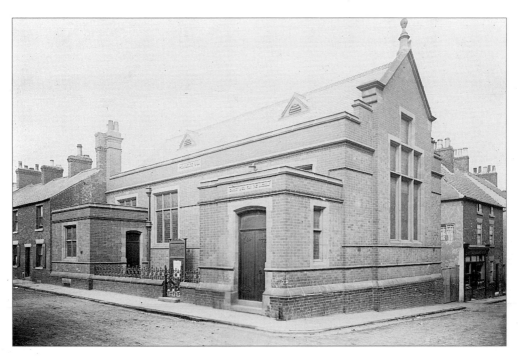

Providence Hall was a Free Church meeting house at the junction of Mount Street and High Pavement, occupying part of the site of the Sutton Centre complex. These two pictures show the exterior and interior of the building. It was built in 1898 and the pastor was Mr T.C. Barratt.

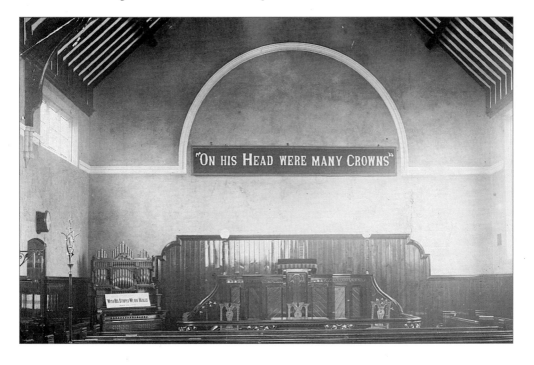

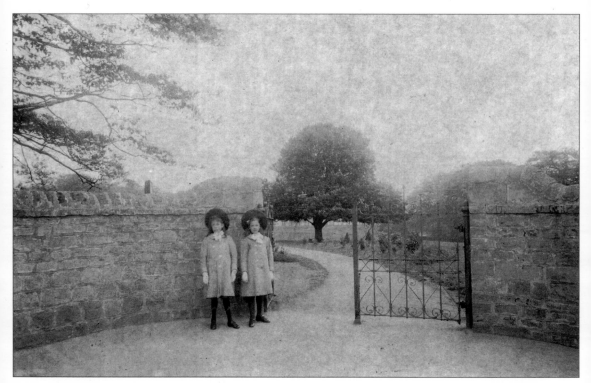

The entrance to the Lawn Park, with the photographer's daughters. In his *History of Sutton-in-Ashfield*, Lindley writes that 'The Lawn Pleasure Ground which is the most picturesque place in the parish, comprises an area of about 20 acres. It was leased for 21 years by the Sutton Urban District Council, for the benefit of the inhabitants, from the representatives of the Unwin family, in 1903. It is a much favoured spot for the holding of alfresco gatherings.'

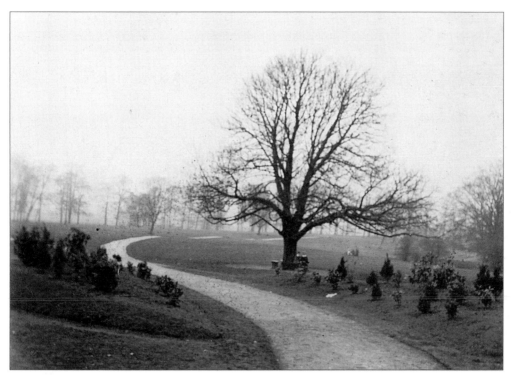

Another view of the Lawn Park. Many of the saplings have grown into huge trees, some of which have been blown down during storms. The park looks quite different today.

The Mill Dam was dug for the use of the Old Mill, using the water from the River Idle, but with the opening of the Lawn Park its recreational use was developed and it was used for fishing and boating.

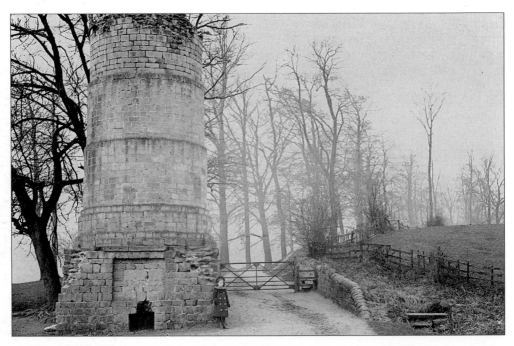

A feature of the Lawn Park which has unfortunately disappeared was a round stone-built tower which stood near the gate leading to Lucknow Drive. The origin and purpose of the tower caused a certain amount of speculation, but it was probably a folly. The above picture shows the tower from the outside of the park and on the right is a sheep-wash.

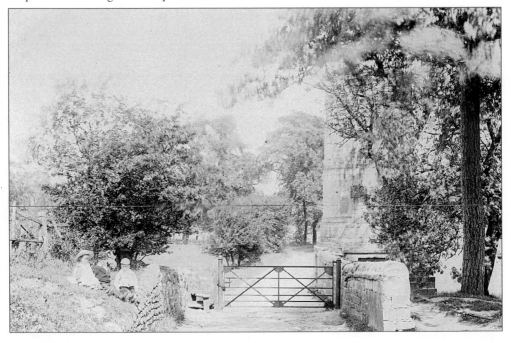

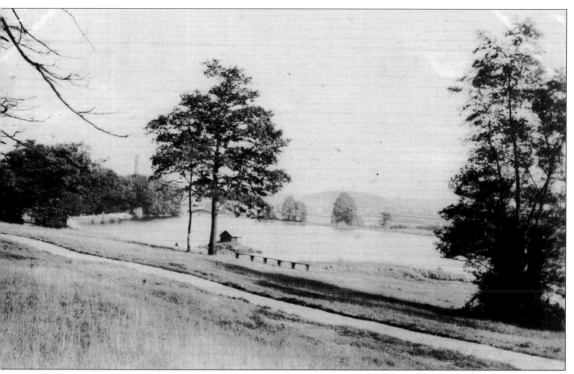

Here are two more views of the Mill Dam. The photograph below shows the boathouse on the island.

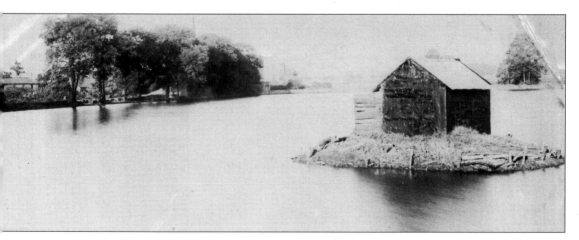

At certain times of the year the Mill Dam attracts large numbers of water birds and orinthologists.

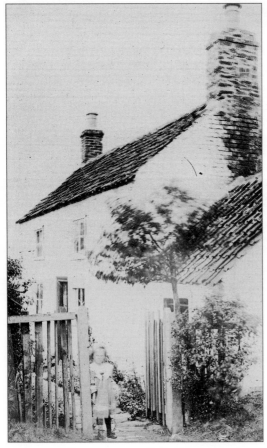

These pictures were taken on Calladine's Lane, off Willowbridge Lane. The photograph to the left shows one of the cottages in the lane. Pantiles were commonly used as roofing material in this area as they could be made from local clay.

FURTHER AFIELD

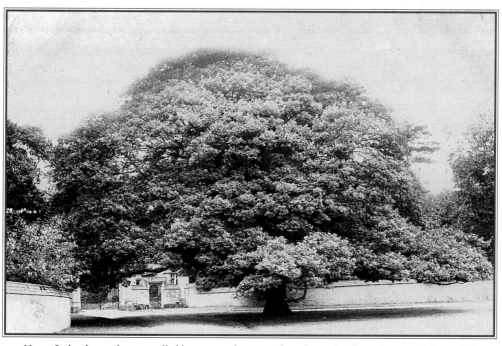

Harry Pickard must have travelled by pony and trap to places beyond walking distance. Pilgrim Oak enhances the entrance to Newstead Abbey grounds on Nottingham Road.

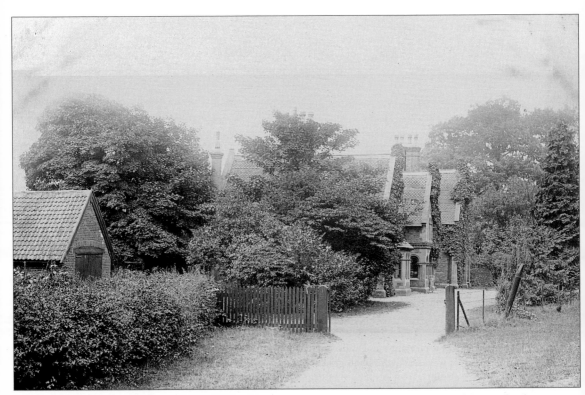

Near Newstead Abbey gates on the Nottingham Road stands the Hutt Restaurant, a building with a long history. In Edwardian times it was called Temperance Hutt.

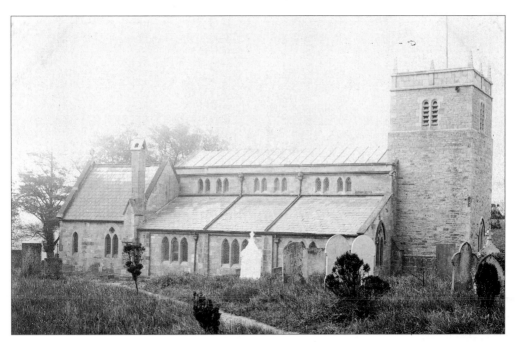

Skegby Bottoms was a pleasant rural walk from Stoneyford Road to Skegby and it is likely that W.H. Pickard walked that way to take this photograph of St Andrew's Church.

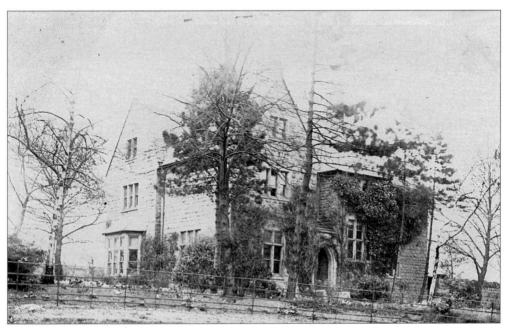

Church of England clergy often lived in large and imposing houses which in modern times are found to be too big and inconvenient. Here we see Skegby Vicarage, near the church.

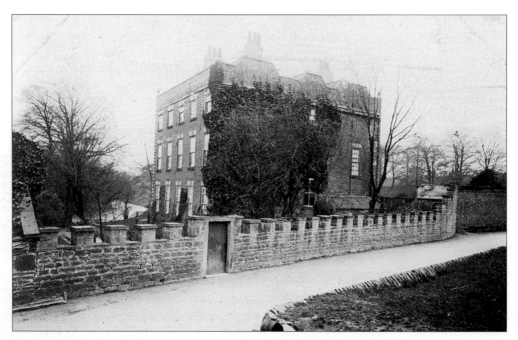

Not far from Skegby church, on the opposite side of the road, is Skegby Hall, the seat of the Dodsley family. In more recent times it has been used as an approved school.

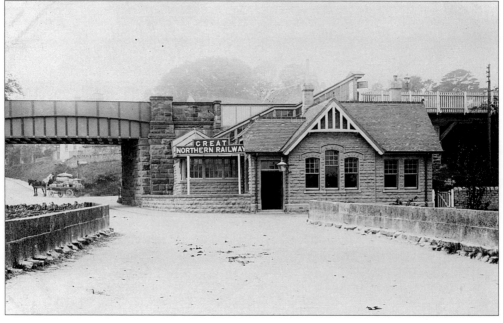

Skegby had a station on the Great Northern line. The horse-drawn cart under the bridge is probably collecting goods brought by rail. The station closed in 1952.

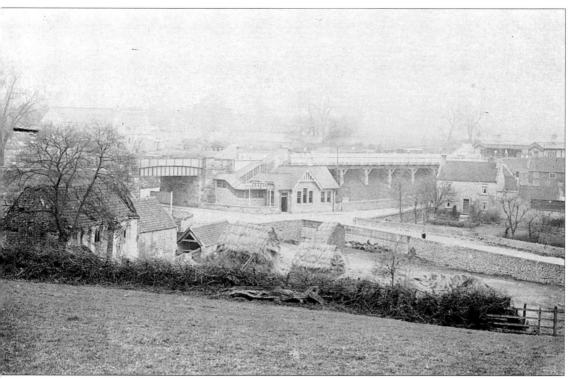

In this picture of the railway at Skegby we also see, on the left, the ruins of Skegby Manor House, an important medieval building.

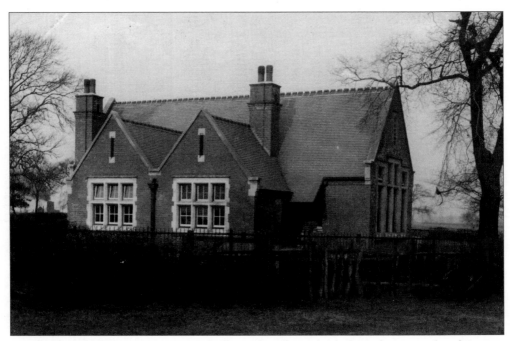

A walk over the field brings us to Teversal village. The village school, shown here, must have been new when W.H. Pickard took the photograph as it was built in 1906. .

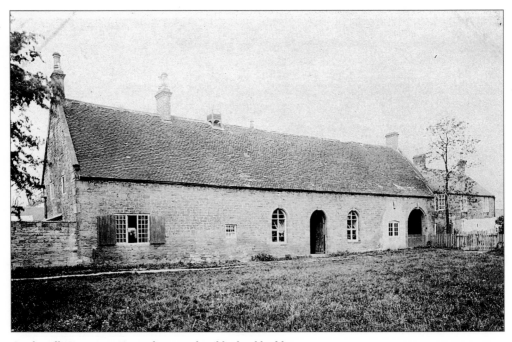

On the village green at Teversal we see the old school building.

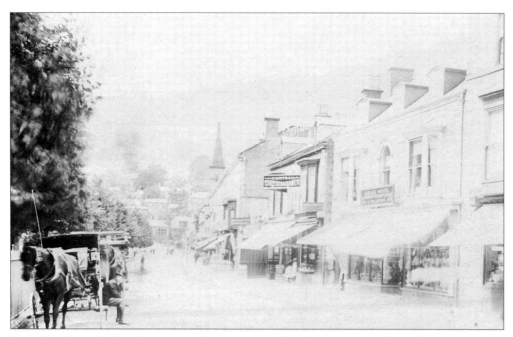

Matlock and Matlock Bath were popular resorts in Edwardian times. Both residents and visitors appreciated the atrractive setting, surrounded by the Derbyshire hills.

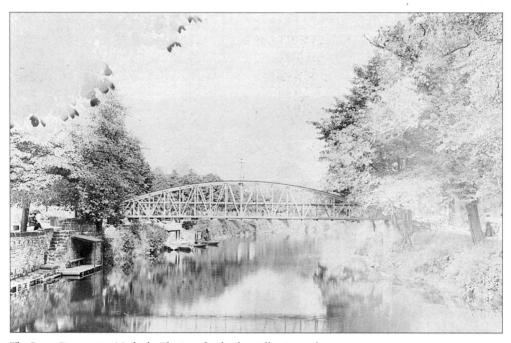

The River Derwent at Matlock. The iron footbridge still exists today.

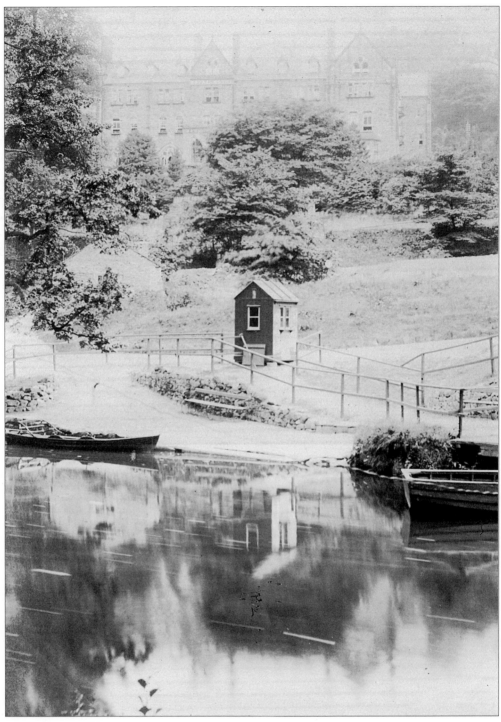

Sutton people may have come to Matlock and Matlock Bath for a holiday or a day excursion as both were accessible by rail or wagonette. The wealthy would come to 'take the waters' and visitors would be fascinated by the 'petrifying wells' where objects placed in the fountains would be covered by a limestone deposit making them appear to be turned to stone. Here we see boats on the River Derwent.

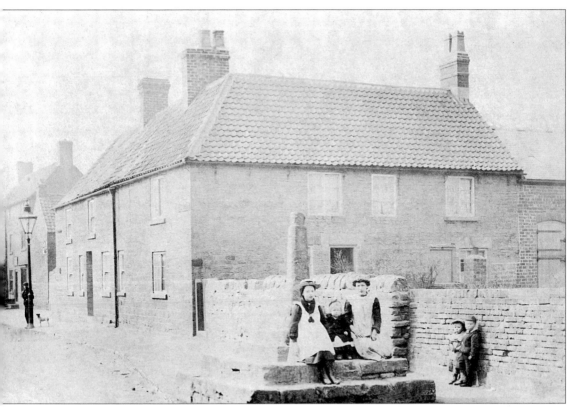

Kirkby Cross was a mile walk from Alpha Cottage along Kirkby Lane, as it then was, passing by the 'Rush-beds'. It probably dates back to 1261 when a charter was granted to Kirkby for the holding of a market. It is, of course, made of local magnesian limestone and if it ever had a crosspiece to the shaft it must have disappeared long ago. Today there are not so many steps visible as the lowest has been buried by the raising of the pavement; it is in danger from heavy traffic and has been damaged more than once in recent years.

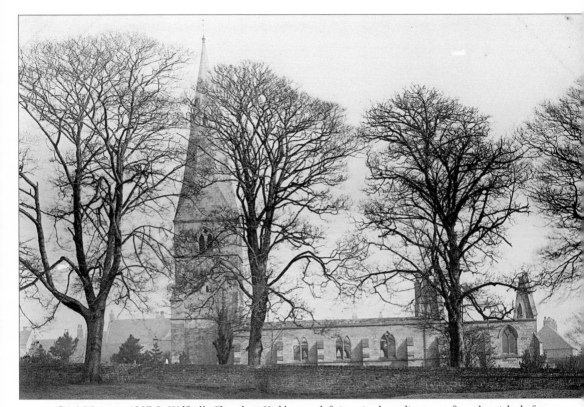

On 16 January 1907 St Wilfrid's Church at Kirkby was left in ruins by a disastrous fire, the night before All Saints' Church at Annesley suffered a similar tragedy. This photograph must have been taken soon after the fire as there is still no roof on the church.

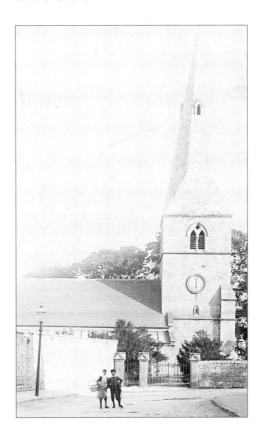

This photograph was taken following the rebuilding of St Wilfrid's.

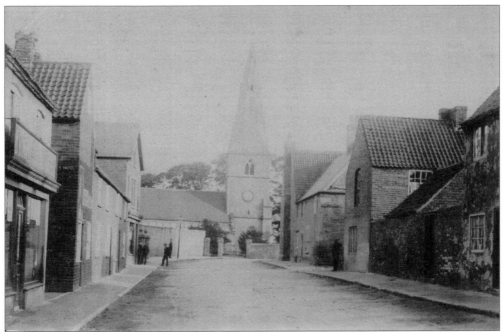

Church Street was the main street in old Kirkby, built in local limestone and with numerous 'yards' coming off the street, each with its own group of cottages. Here we are looking southwards towards St Wilfrid's Church.

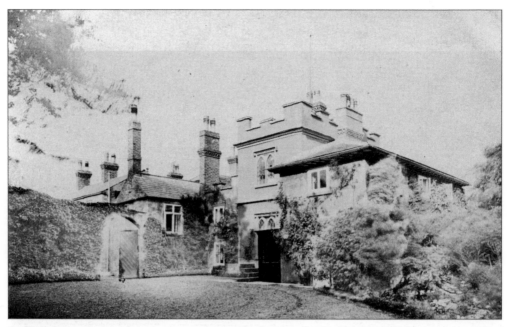

St Wilfrid's stands on a limestone escarpment overlooking the Coal Measures and, at the bottom of Church Hill, Pinxton Lane leads westwards. Langton Hall, on the left side of this road, was the home of the Salmond family.

Nearly opposite Langton Hall on Pinxton Lane, Cliff Farm has been the home of the Edge family for many generations.

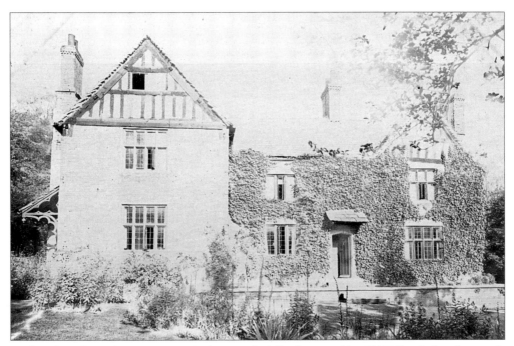

Further along the road to Pinxton, at the bottom of Cliff Hill was Kirkby Old Hall, which unfortunately fell into disrepair and had to be demolished.

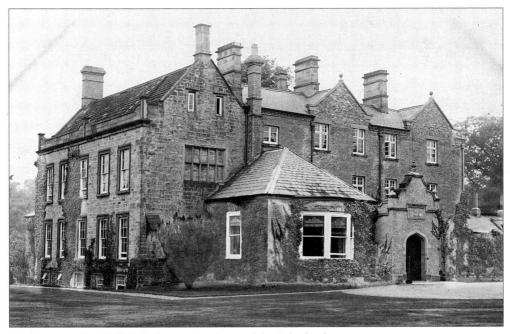

Not far away is Brookhill Hall, the one-time home of the Coke family.

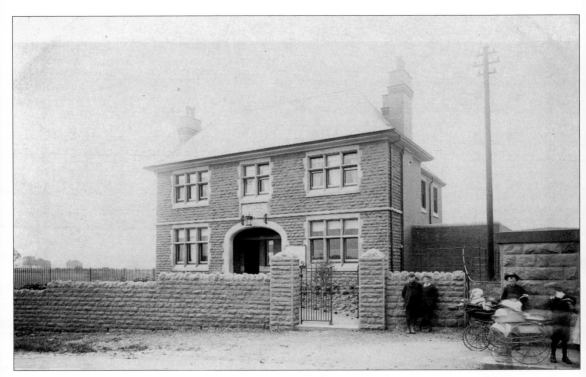

Kirkby police station today looks very similar to this picture which my grandfather took. In Edwardian times there was no need for parking space for police cars and within the boundary wall (which is now lower) was a garden.

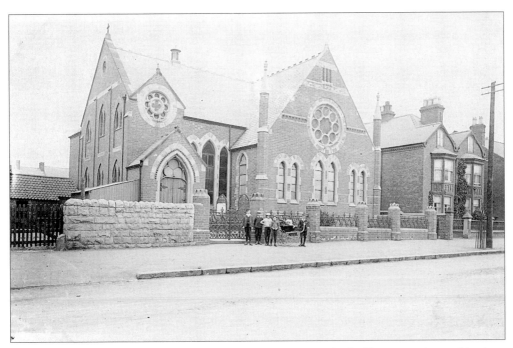

East Kirkby Wesleyan Chapel at the bottom of Diamond Avenue. This building was redesigned in about 1961 on amalgamation with the Bourne Church and is now called Trinity Methodist Church.

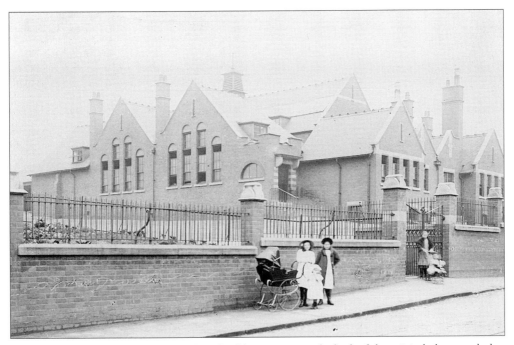

It is unclear which school this is. 'Kirkby Schools' is written on the back of the original photograph, but the building is certainly not in Kirkby.

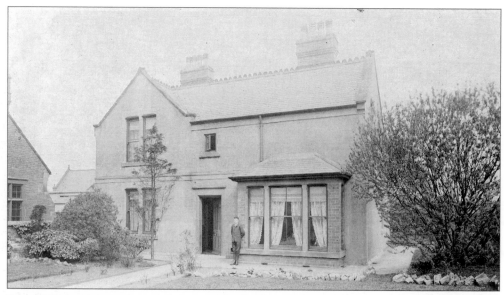

School House, adjoining Diamond Avenue School. The photographer's brother, Thomas Pickard, was headmaster of the school and on his retirement was succeeded by his son, Charles Pickard, who lived in this house until his retirement. The young Charles is seen here in front of the house.

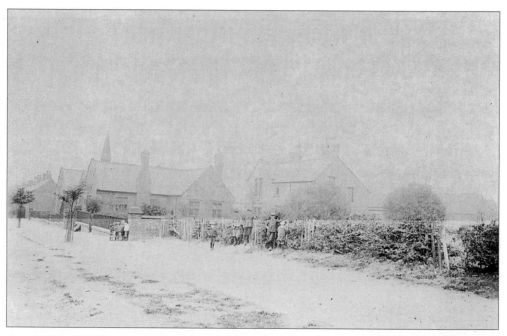

Forest Hill, East Kirkby, was named Diamond Avenue in honour of Queen Victoria's jubilee. This picture was taken when there were only houses at the bottom of the hill and when there was no pavement beside the road.

St Thomas's Church on Kingsway at Kirkby, built in 1901. Harry Pickard's brother, Thomas, was the organist at one time.

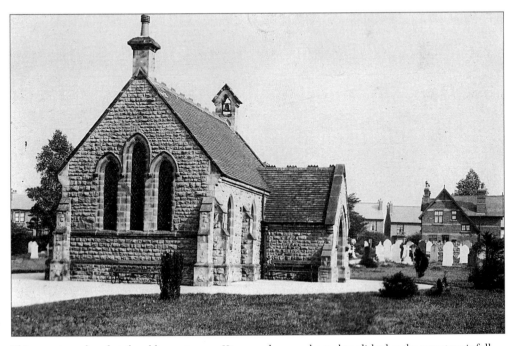

This cemetery chapel at the old cemetery on Kingsway has now been demolished as the cemetery is full.

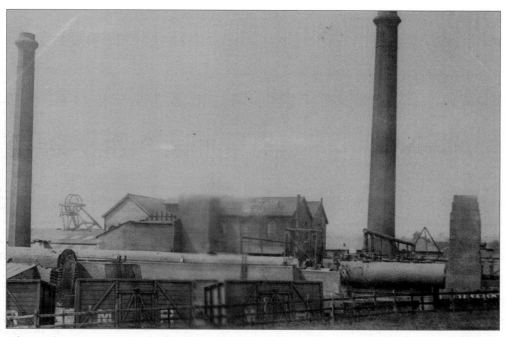

When coal-mining was in its heyday Kirkby Colliery, shown here, was served by the LMS Railway with engine sheds and marshalling yards along Lomoor Road covering the town with a pall of smoke.

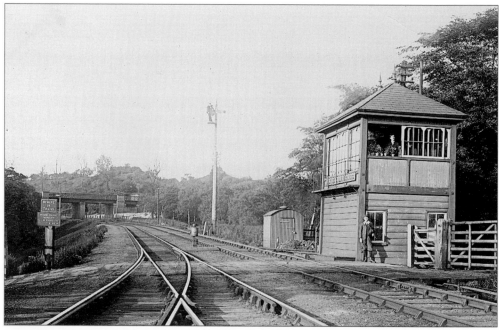

This signal box on the old LMS Railway is at the junction near 'The Quarries', controlling the line to Bentinck Colliery.

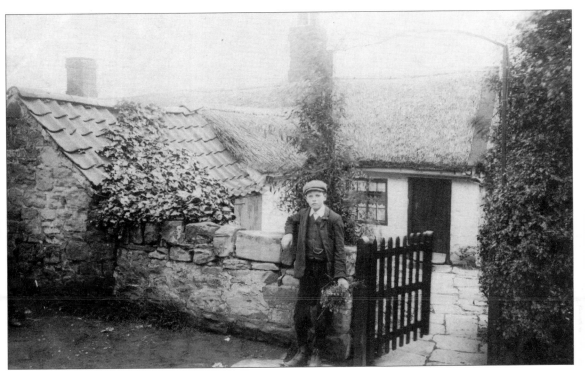

A cottage near Tibshelf, built of local limestone and thatched. The young man in the picture would no doubt be very proud of his pocket watch in his waistcoat pocket as he shows off its chain.

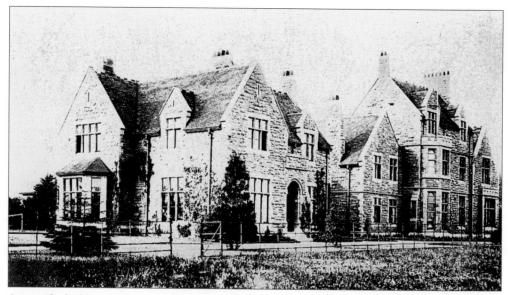

Queen Elizabeth's Boys' Grammar School on Chesterfield Road, Mansfield. The school was founded in 1561, but the present building (seen above) dates from 1879, and succeeded the one in the centre of the town. It has now combined with Queen Elizabeth's Girls' Grammar School and is known as the Queen Elizabeth's Upper School.

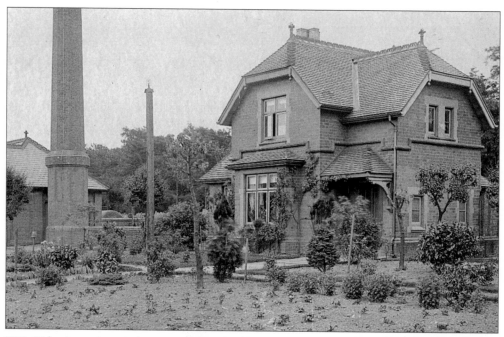

W.H. Pickard must have made quite a journey to take this picture, probably travelling by pony and trap. It is the pumping-station near Redmile, beyond the Seven-mile House, on the way to Nottingham.

RURAL SCENES

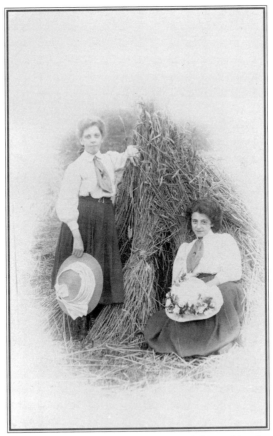

In this cornfield scene are the photographer's daughter, Annie (left), and her friend, Florrie Marshall.

The whole area behind Alpha Cottage was called 'The Weeds' and there was a pleasant walk through the
fields, not quite so accessible in these days, via a footpath from Spring Bank.

'The Dumbles' is a deep wooded ravine with a
stream in the bottom. It used to be a popular
walk, either from 'The Weeds', from Fulwood
or from Doles Lane at Kirkby.

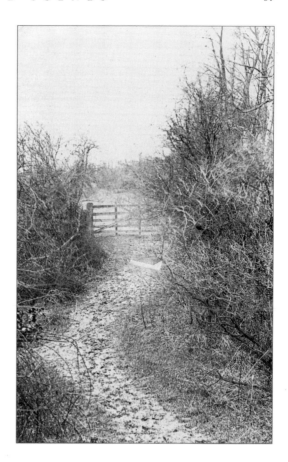

This is a view of 'The Dumbles' path often still accessible, but muddy and overgrown.

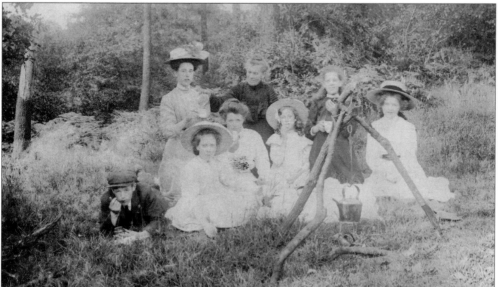

A picnic in 'The Dumbles'. Harry and Eleanor must have taken their numerous nephews and nieces out on excursions frequently. This must have been one of the occasions when Eleanor's sister and family were visiting from Mytholmroyd in Yorkshire. Here Eleanor, the lady in the dark dress, is not wearing a hat.

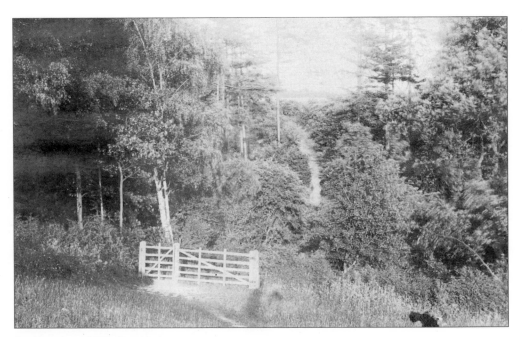

Another view of 'The Dumbles'.

An old Roman track called the Old Newark Road, once carrying lead from the Derbyshire mines, runs through Sutton and going from Sutton Junction towards Rainworth passes Cauldwell Wood, shown here.

SOME PERSONALITIES

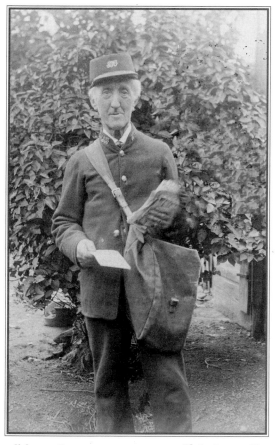

Josiah Truman was a well-known Sutton postman in my grandfather's time. He is seen here in the uniform of the day.

Herbert Clarke lived on Brookside (now called Brook Street), near the swimming baths. He was well known as the owner of 'The Shop Without a Door'. Apparently he served customers from the window. This picture shows the rear of his house.

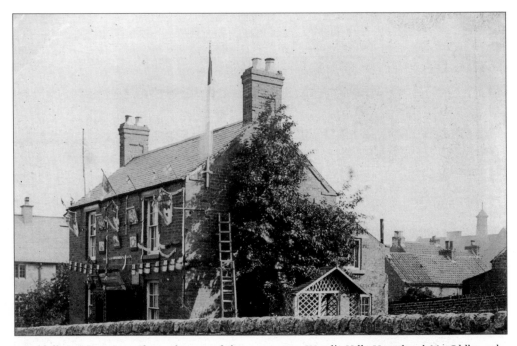

Brookhill Court now stands on the site of this cottage on Wood's Hill. Here lived Mr Oldham the chimney-sweep. He was a keen gardener and the soil in his garden was black with soot. Beside his cottage were stacked bags of soot for sale for garden use. It was said he made more money from the sale of soot than from actually sweeping the chimneys. The cottage is seen here decorated for the coronation of 1911.

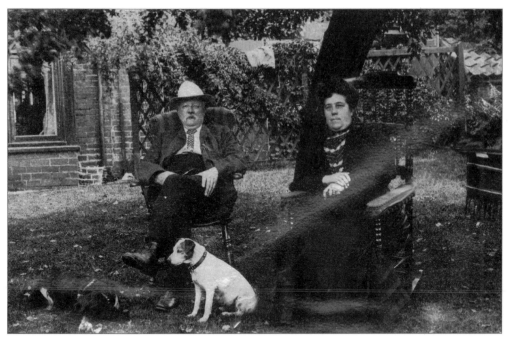

An eminent Suttonian was Mr John Craster Sampson, at one time chairman of the Urban District Council. He is seen here with his wife. Craster Street is named after him.

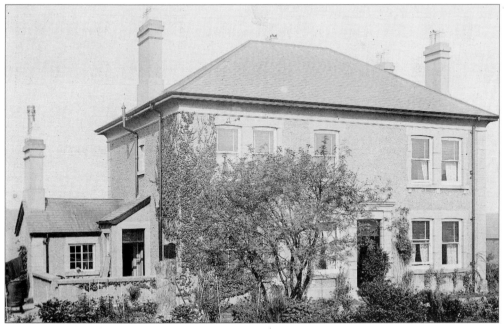

Spring Bank House. Lindley wrote in his *Sutton History*, 'This mansion, the residence of Mr J.C. Sampson, is situated at the entrance to Kirkby road and was erected in 1895. It stands on the site of a farmstead which was formerly occupied by a farmer named Hall.'

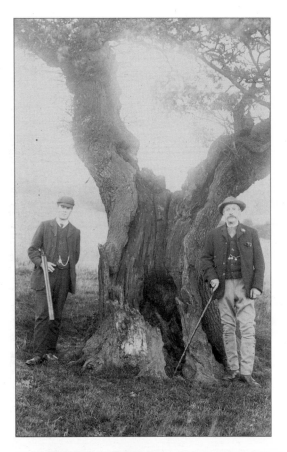

George Keeton (with gun) and perhaps his father.

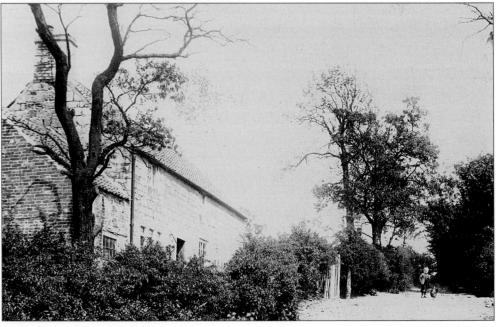

This is the cottage where the Keeton family lived.

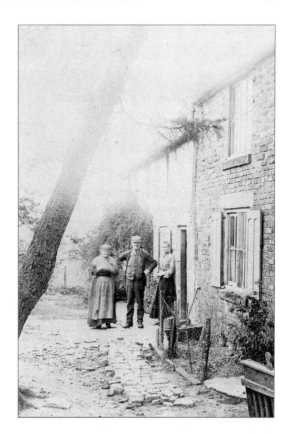

The gamekeeper and his family at their cottage in Spring Wood.

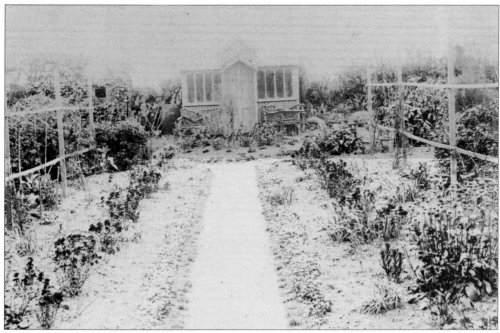

When people needed to eke out a living by growing as much of their own food as possible there was often much competition in gardening. This is Mr Bristol's garden.

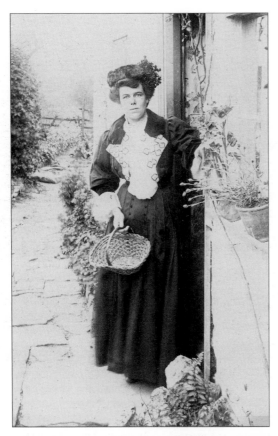

Mrs Whitaker, a lady who lived on Calladine's Lane.

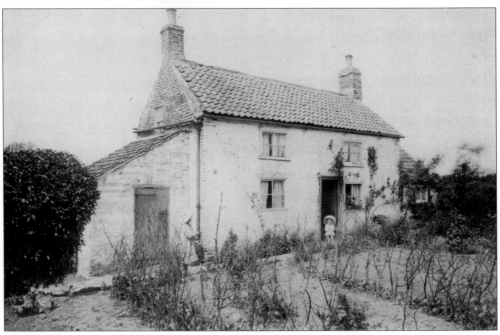

The Whitakers' cottage on Calladine's Lane, off Willowbridge Lane.

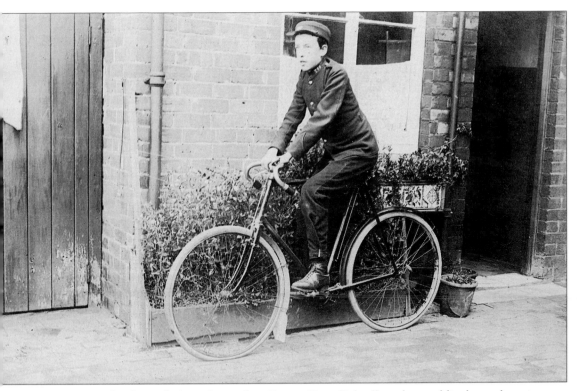

Albert Dove, when he worked as telegram boy. He was Harry Pickard's nephew and lived next door at Beta Cottage. He ran away to sea, boarding a ship at Liverpool, getting a job as cabin boy and eventually becoming chief steward on the SS *Vasari* of the Lamport and Holt line, plying between Boston (Massachusetts) and Buenos Aires. He took US citizenship and married an American, but in the First World War returned to England to volunteer for the army. After the war he returned to the USA, but died as a result of his war service in France.

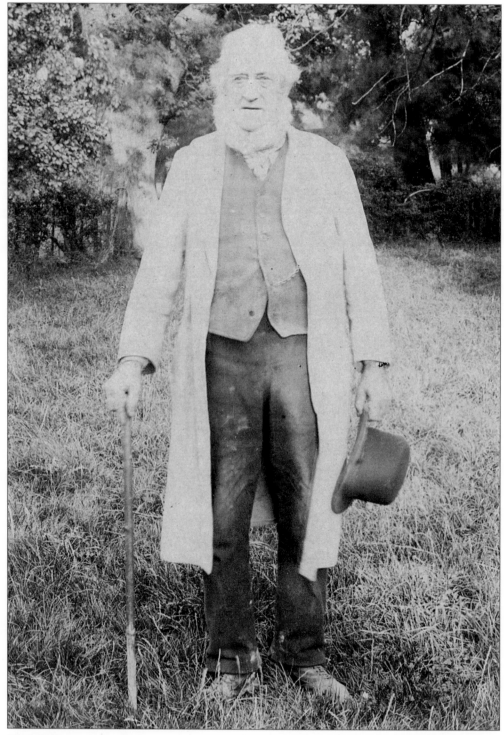

Edward Edge was a friend of Harry Pickard. He lived at Cliff Farm, Pinxton Lane, where his descendants still farm. Edward died on 27 February 1905 in his eighty-third year and is buried in Kirkby Old Cemetery, near St Wilfrid's.

INDUSTRY & FARMING

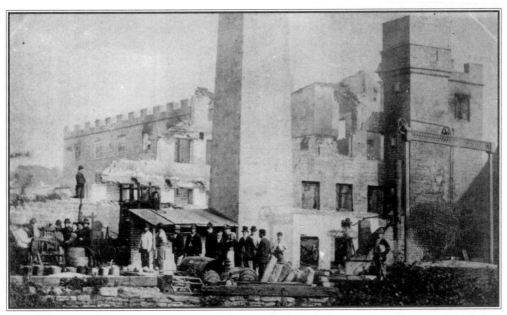

This photograph of the Old Mill, as it was called, may have been copied by my grandfather from an earlier photograph. Very little now remains of the building as the site is being redeveloped. It stood at the end of Lucknow Drive and made use of the Mill Dam which now forms part of the Lawn Park. I believe my grandmother, Eleanor Bown, worked there before her marriage to Harry Pickard.

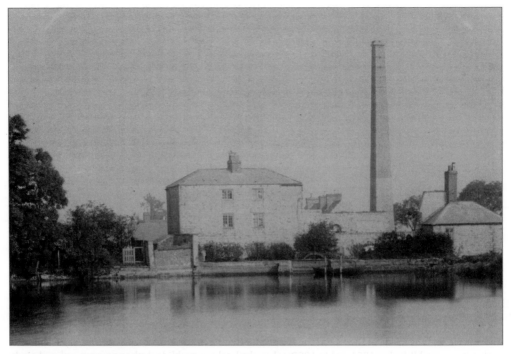

Another view of the Old Mill with the dam in the foreground.

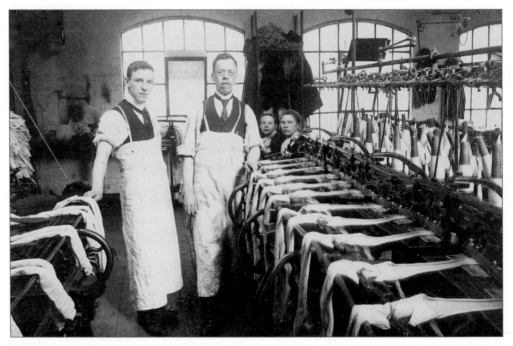

The interior of John Pickard's hosiery factory on Cursham Street. Of the two men tending the machines, the one on the right is John Pickard jnr, brother of the photographer. The two young ladies in the background are probably employees at the factory.

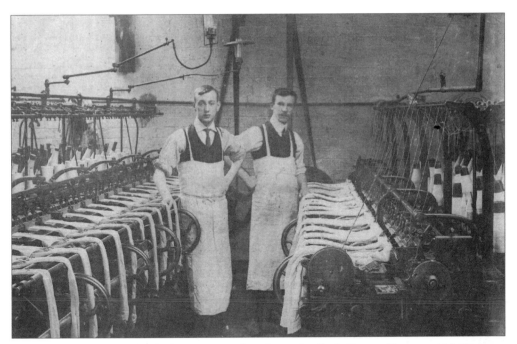

Another view of the inside of the factory on Cursham Street. Lindley's *History of Sutton-in-Ashfield* informs us that it was established in 1854 and in 1907, when the book was published, the number employed, male and female, was fifty.

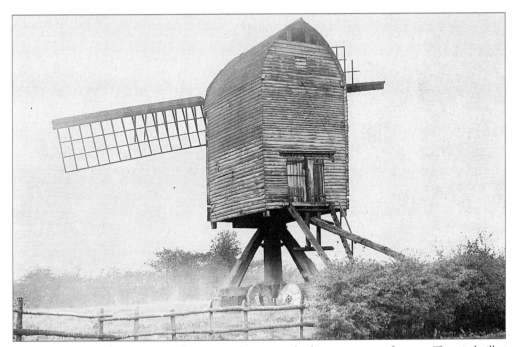

At the beginning of the century wind power was becoming obsolete as a source of energy. The windmill at Sutton Junction (see page 95) was still in use in Edwardian times, but this post mill was in ruins. It was situated on the road to South Normanton.

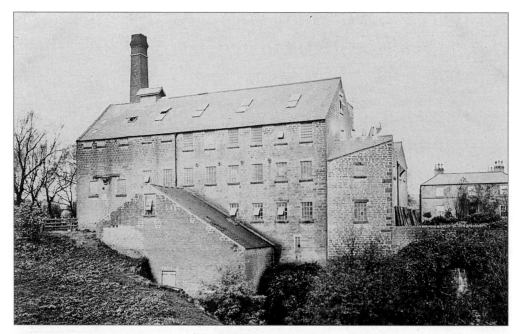

King's Mill was an old-established flour mill, but more recently was used for the production of animal feed until it was destroyed by fire. The mill used the water of the River Maun for power, the water supply being enhanced by the digging of King's Mill Reservoir in the 1920s.

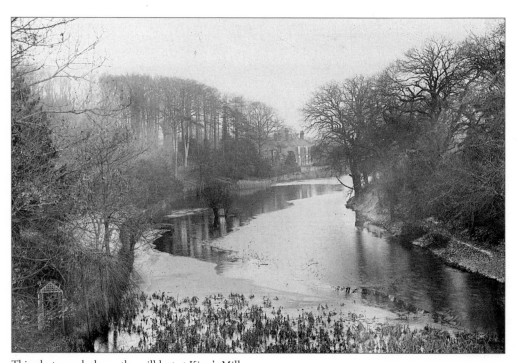

This photograph shows the mill leat at King's Mill.

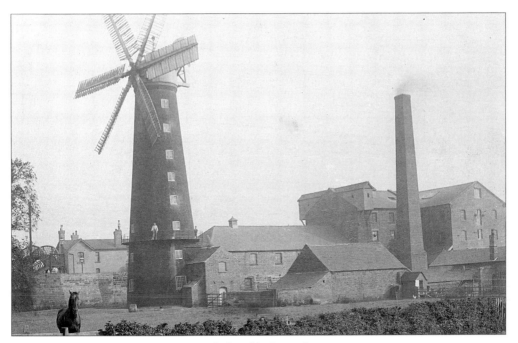

The tower mill at Sutton Junction was very high and had six sails.

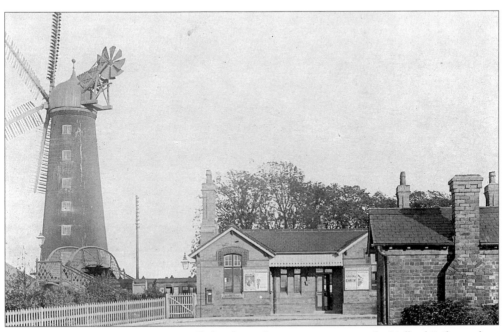

This picture of Sutton Junction tower mill also shows the Junction station on the Midland Railway where passengers for Sutton changed on to the branch line for the ¼ mile journey to Sutton Town station.

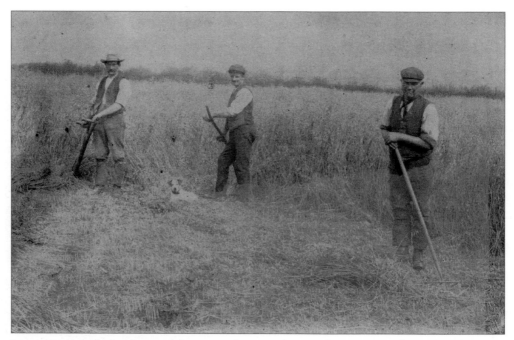

In my grandfather's day there was far more subsistence farming than commercial specialization. Grain crops were still for local use and hay was grown to feed the animals. Here we see harvesting in progress, using the scythe to cut the crop, which would be bound in sheaves by hand.

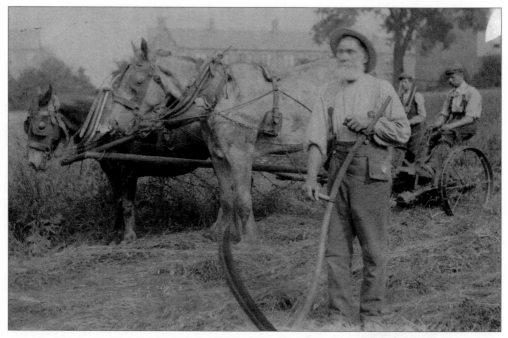

Haymaking is taking place in this scene. After cutting by scythe or horse-drawn mowing-machine, the hay was loaded on to the hay cart by men with the pitchforks.

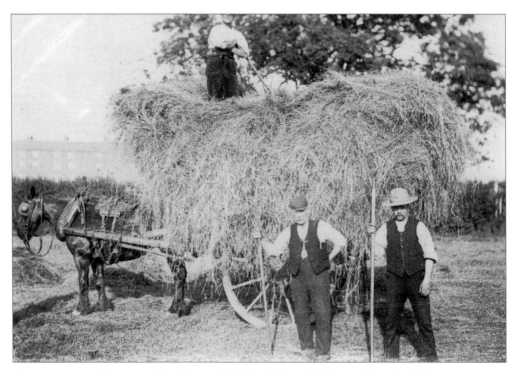

This picture was taken in one of Mr Sampson's fields and shows the hay cart being loaded.

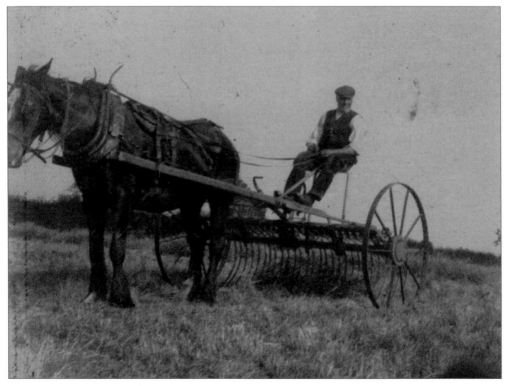

The hay remaining on the ground was gathered by a horse-drawn rake such as the one seen here.

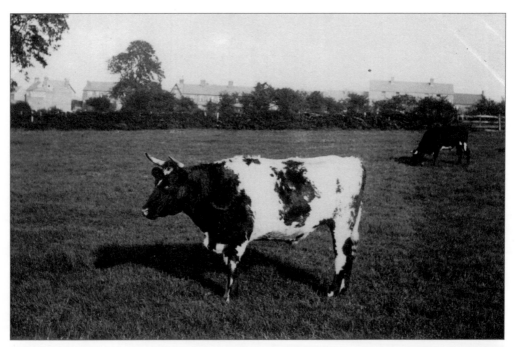

Farming in this area was mixed farming and here are some of Mr Craster Sampson's animals. Presumably the donkeys were used as draught animals.

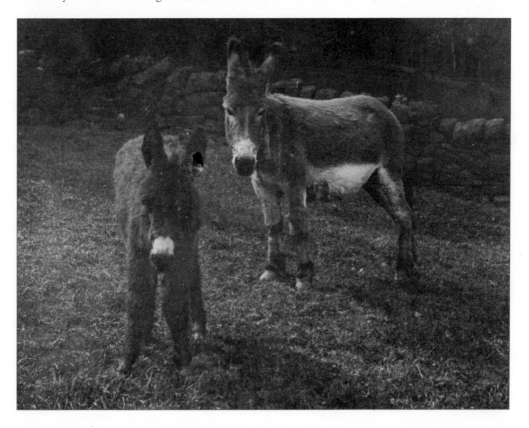

TRANSPORT

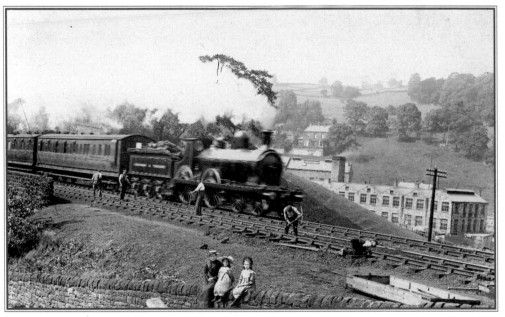

An express train. My mother always said that her father was very proud of this picture. It was, she said, taken at an exposure of 1/90 of a second.

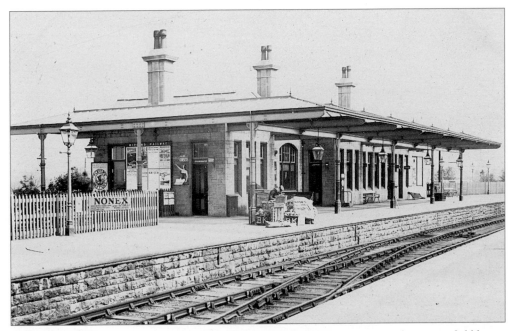

Sutton Town station on the Midland line, taking passengers to join the main Nottingham–Mansfield line at Sutton Junction. It was the *Penny Emma* which plied up and down this ¾ mile stretch. For a long time the fare was 1*d* single and 1½*d* return.

This is the station at Sutton Junction.

Wood End station was between Huthwaite and Tibshelf.

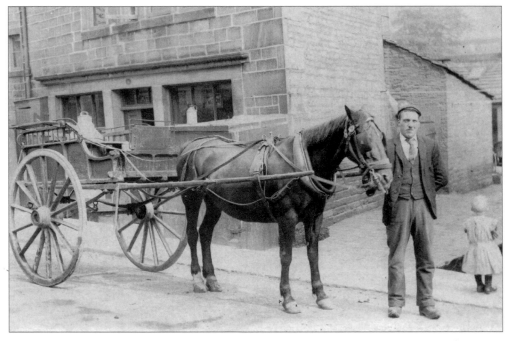

Here we see a typical method of delivering milk. This cart was actually at Mytholmroyd, Yorkshire and the milkman was Fred Eccles.

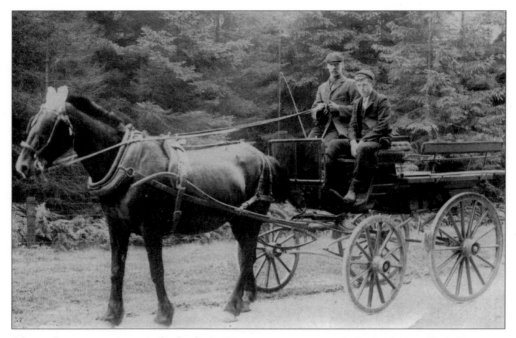

A horse-drawn wagonette, popular for day outings.

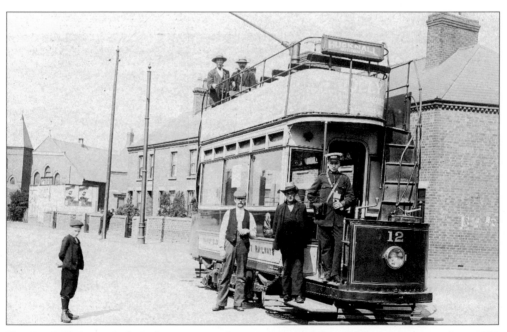

The Mansfield District Light Railway ran trams between Mansfield Woodhouse and Huthwaite from 1905 to 1932. This picture shows the Huthwaite terminus. Huthwaite at that time was called Hucknall-under-Huthwaite. In the background can be seen the New Fall Street Primitive Methodist Chapel.

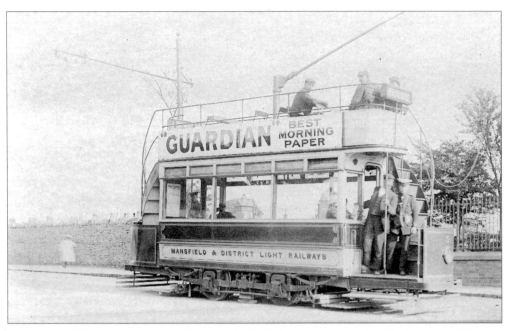

Here is one of the trams near Sutton Cemetery. In 1932 the trams were replaced by buses: the 101 route provided an excellent ten-minute service all through the day.

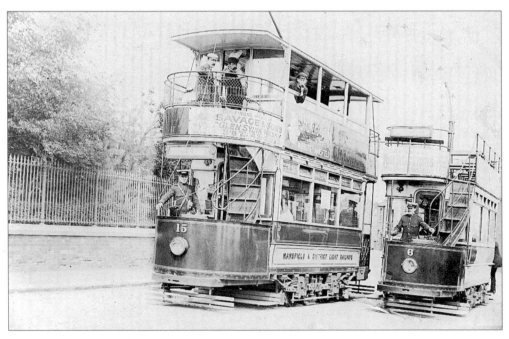

The trams used single track rails, but there were loop-lines for passing. Here we see two trams passing near Sutton Cemetery.

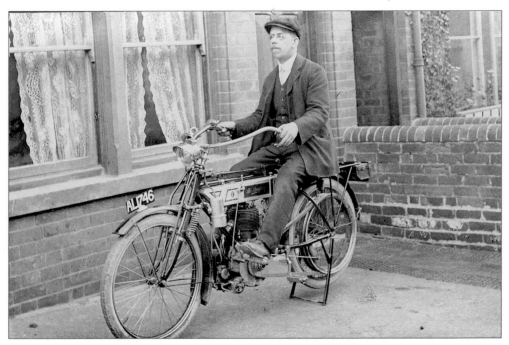

This light motor cycle was owned by John Pickard, the photographer's brother. He is outside Beta Cottage.

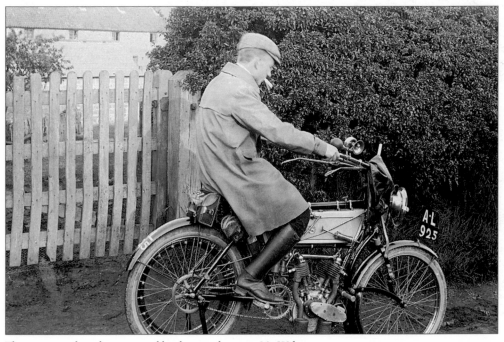

This motor cycle is demonstrated by the proud owner, Mr Walton.

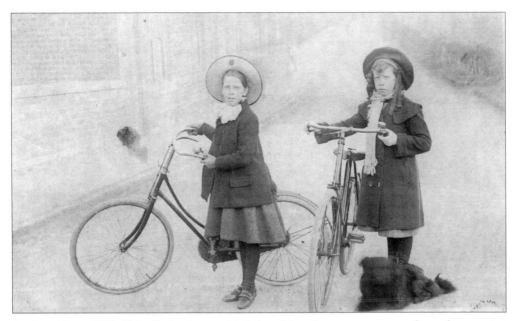

Annie and Janet, W.H. Pickard's daughters, with their pedal cycles — a very common form of transport at that time.

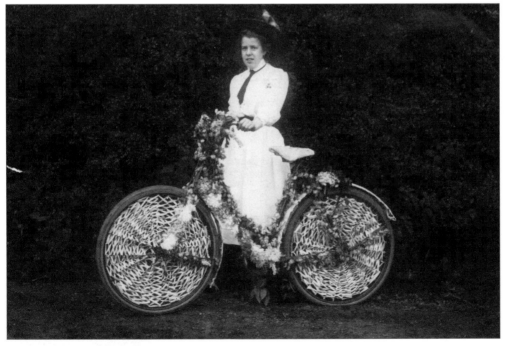

Harry Pickard's niece, Winnie Dove, next door with her cycle — probably decorated for the coronation of 1911.

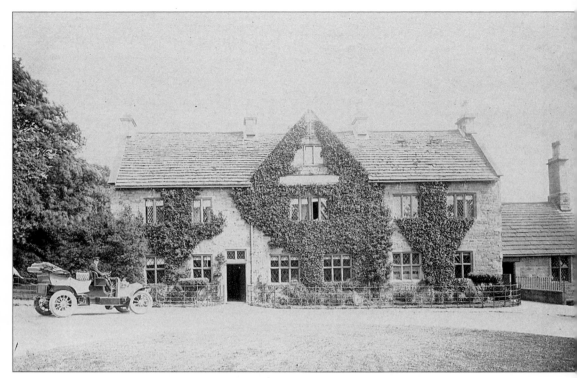

This picture of Hardwick Inn has been included here because on the left is a fine example of an open-topped car of the time. Hardwick Inn is near the entrance to Hardwick Hall grounds not far from Teversal.

FASHION

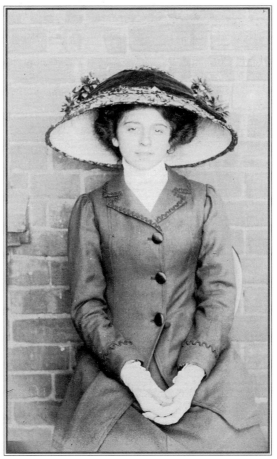

Large hats seem to have been very much in vogue in Edwardian times. Nellie Proctor, a friend of my mother and daughter of the Primitive Methodist minister, seems to have been very fashion conscious.

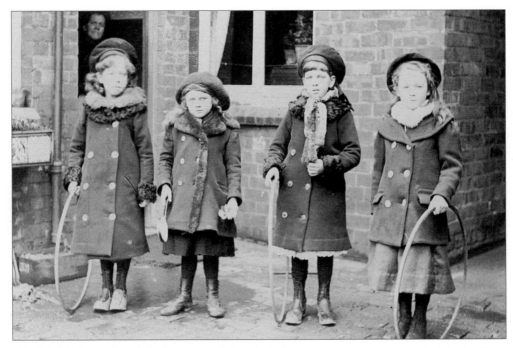

Annie and Janet and two friends wearing their school clothes – warm winter coats and 'sailor' hats. Popular toys were hoops and shuttlecock and battledore.

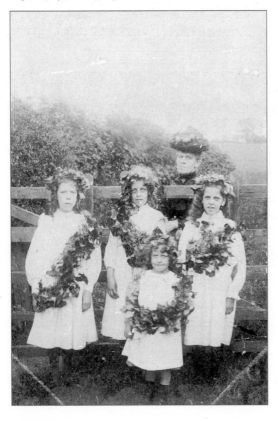

Decked with flowers – Mrs Pickard (wearing the typical large hat) has taken Annie and Janet and their friends for a walk over 'The Weeds' and they have made garlands of wild flowers for the photograph.

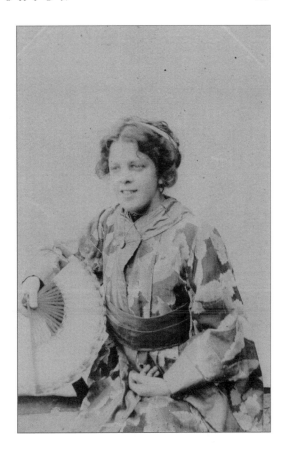

Annie wearing Japanese costume – probably
for an operetta produced by the young people
from the Reform Street Primitive Methodist
Church.

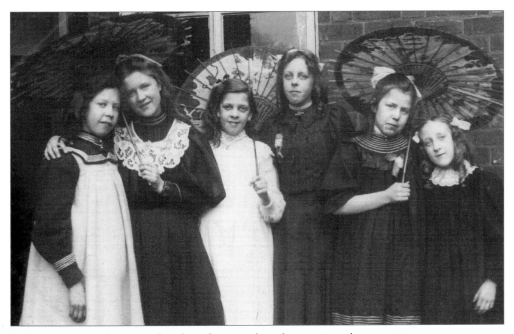

Perhaps these parasols may also have been for some show the young people were putting on.

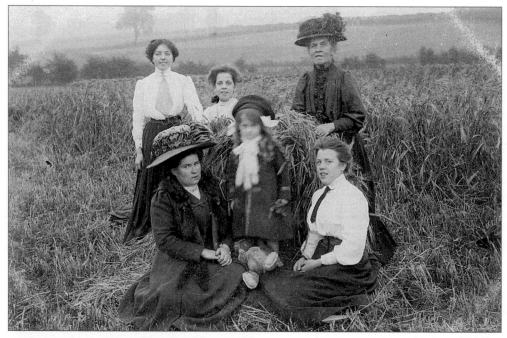

In the corn. Here is Eleanor Pickard with Annie and her cousins.

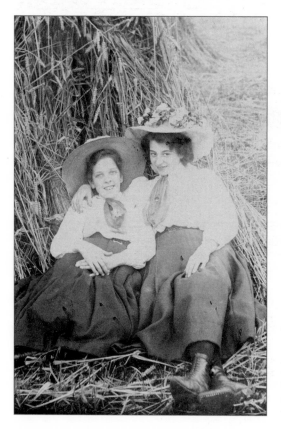

Florrie Marshall and Annie, formally dressed by our standards, even in an informal setting. They are wearing long heavy black skirts, blouses and ties, lace-up boots and the typical large hats.

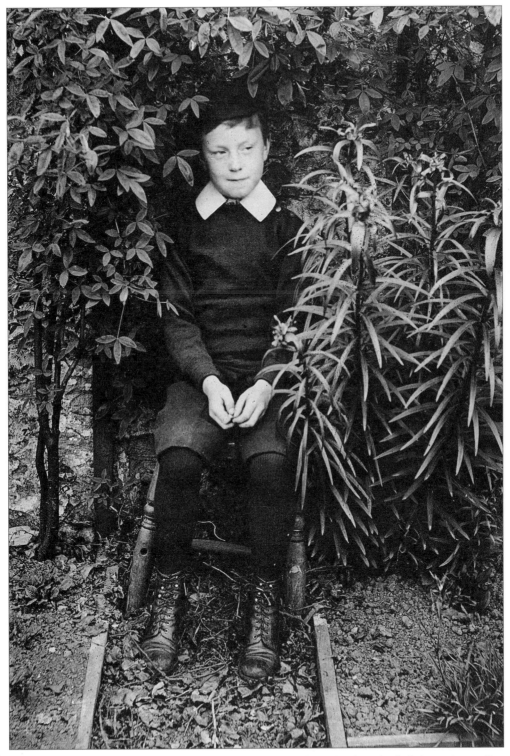

Arthur Dove, W.H. Pickard's nephew, from next door. He is dressed in his school clothes – Eton collar, short trousers, black hose and lace-up boots were typical.

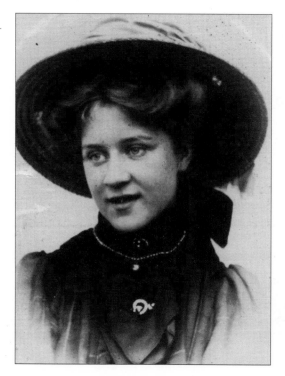

Large hats again!

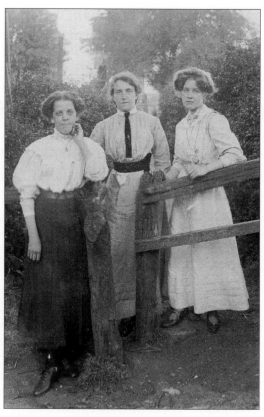

Three serious young ladies, again formally dressed. They were, left to right, Annie Pickard, Lily smith and Nellie Proctor.

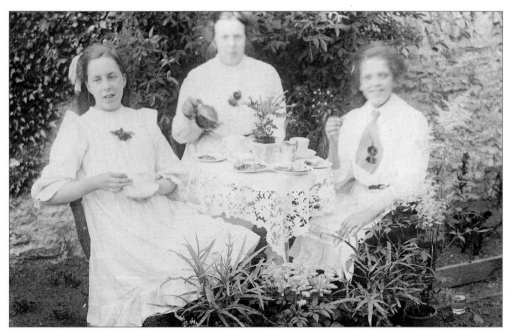

Three little girls having a tea party in the garden. Annie (right) with her cousins from next door. Note the lace tablecloth and flowers on the table.

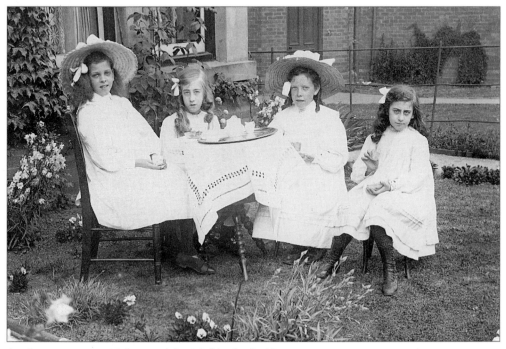

Another tea party – with Janet and Annie's friends, the Mountneys.

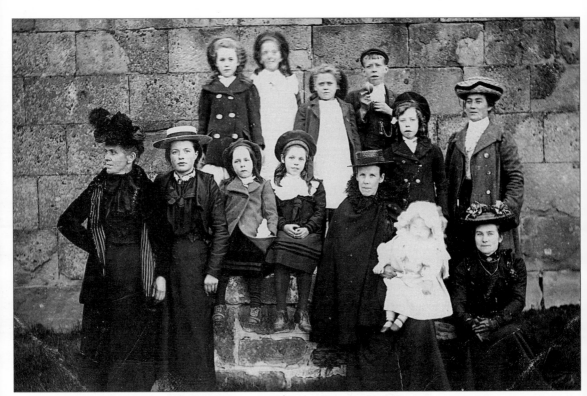

A group of family and friends on a day's outing to Hardwick Hall. Here they are posing round the mounting block outside the entrance. They must have travelled by wagonette. Eleanor (left) and her sister-in-law, Adah Dove (with the baby), seem to have brought their own children and nephew and nieces.

HOLIDAYS

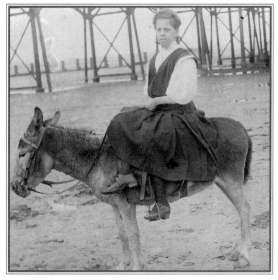

Cleethorpes was in easy reach of Sutton by train and many local people made it their holiday resort. Here is Annie on a donkey.

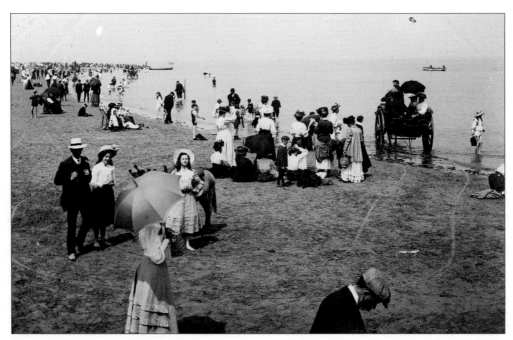

Wherever he went W.H. Pickard would take his camera with him. This picture shows a crowd of holiday-makers very different from a beach scene today. The horse-drawn cart on the right was used to take people out to where the water was deep enough for a boat to approach the shore.

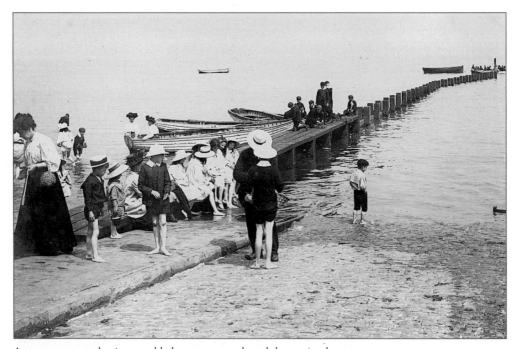

A temporary wooden jetty enabled passengers to board the rowing-boats.

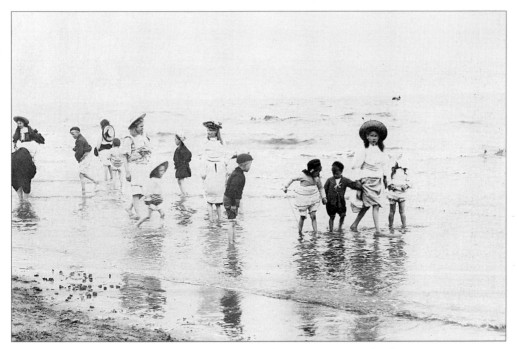

Another beach scene at Cleethorpes. Paddling seems to have been more popular than swimming.

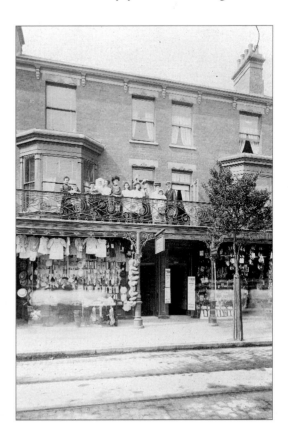

Here is a view of a street in the town of
Cleethorpes. Above the shops there seems to
be a boarding house. The people posing on
the balcony may be members of the family.

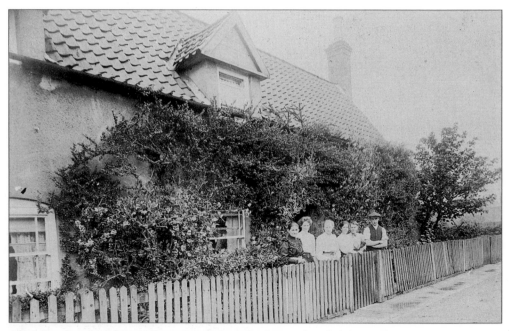

Although only a short distance from Sutton, the Pickards went for a holiday at Edwinstowe on at least one occasion. Here is the cottage where they stayed.

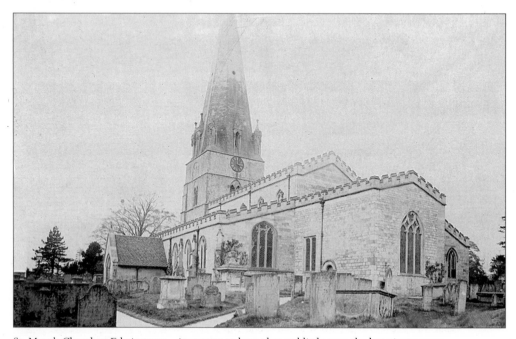

St Mary's Church at Edwinstowe – it appears to have changed little over the last ninety years.

Robin Hood's Larder, one of the great oaks associated with the famous outlaw, was about 1½ miles from the Major Oak.

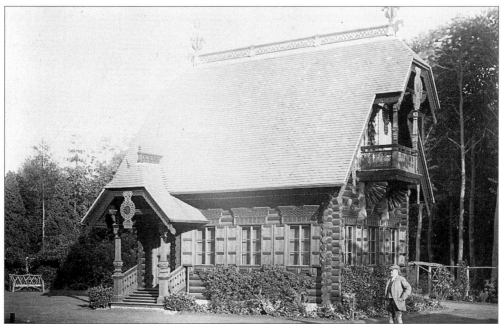

This log cabin, in a Russian style, stood in Sherwood Forest near Robin Hood's Larder. It was built of dovetailed logs and adorned with elaborate carving.

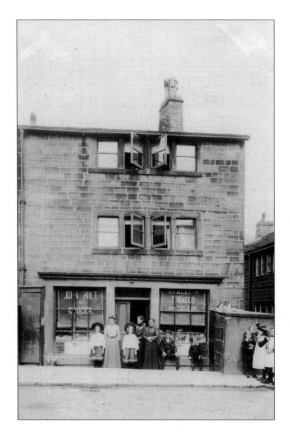

My mother's Aunt Juliet and Uncle John Holt
lived at Mytholmroyd near Halifax and the
Pickard family used to go there for holidays as
often as possible. This is the general store run
by Aunt Juliet while Uncle John was working
(on the canal?).

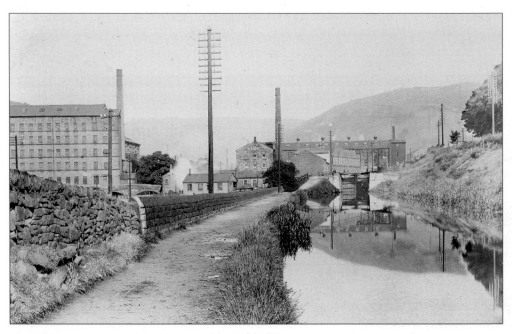

The Calder Canal was situated at the rear of the Holt's shop.

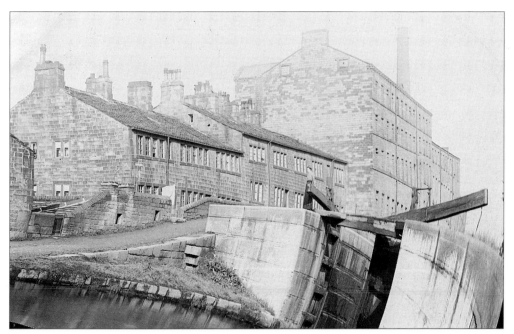

One of the locks on the Calder Canal, close to where the Holt family lived at Mytholmroyd.

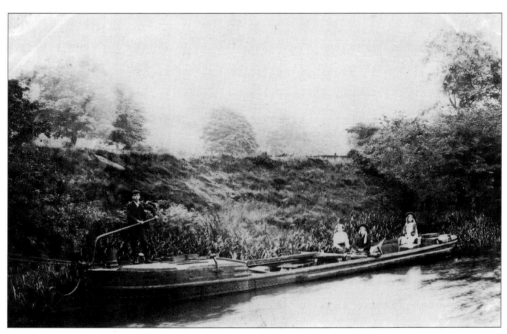

Some of the cousins on a canal barge.

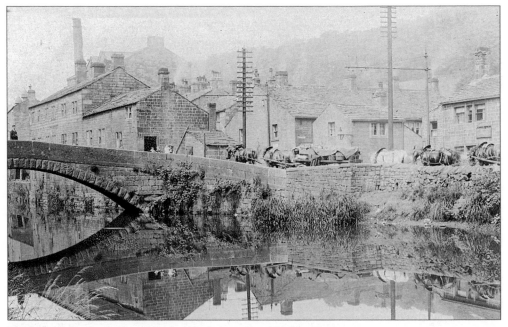

Hawksclough Bridge, halfway between Mytholmroyd and Hebden Bridge.

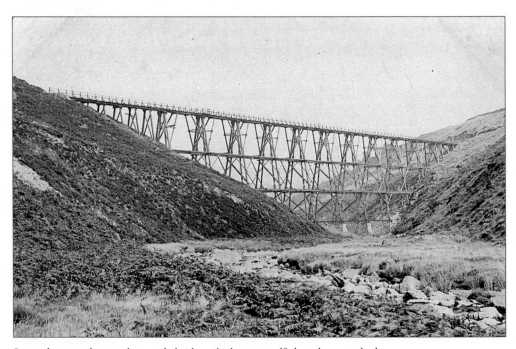

Somewhere nearby was this trestle bridge which my grandfather photographed.

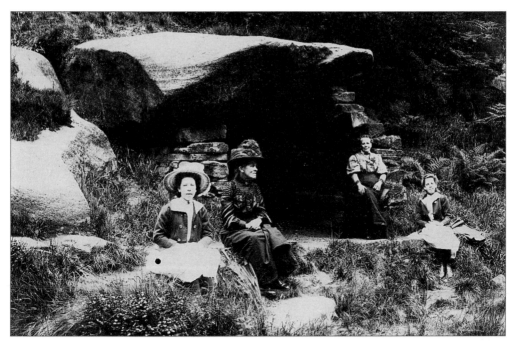

A local tourist attraction was this stone structure called 'The Fisherman's Hut'. It looks as though it could be the remains of a prehistoric burial chamber.

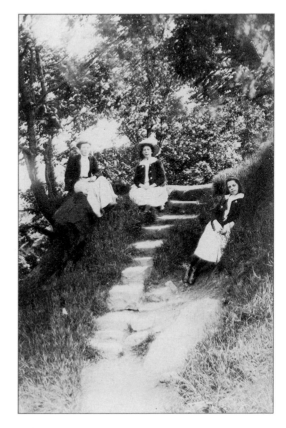

'Granny Steps' was the name given to this place which the family visited when staying at Mytholmroyd.

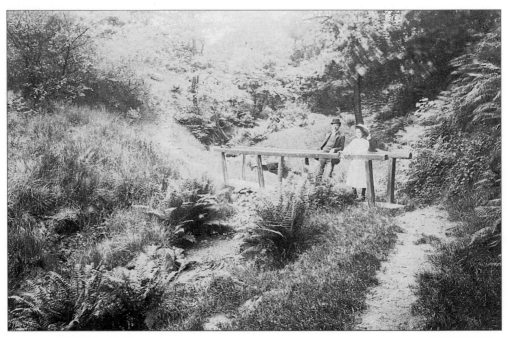

Parrock Clough was another of the scenic places nearby. It was one of the deep wooded valleys carrying a tributary of the Calder, a few miles west of Mytholmroyd.

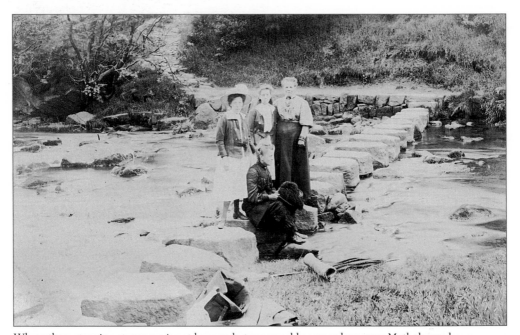

Where these stepping-stones are is not known, but presumably somewhere near Mytholmroyd.

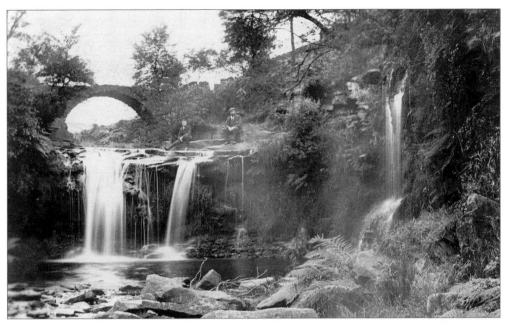

Lumb Falls in Cragg Vale near Mytholmroyd.

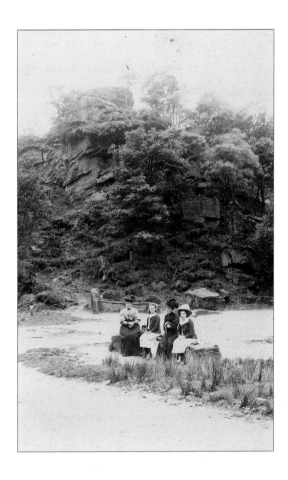

Annie and Janet with their mother and aunt,
sitting at the foot of Hardcastle Craggs.

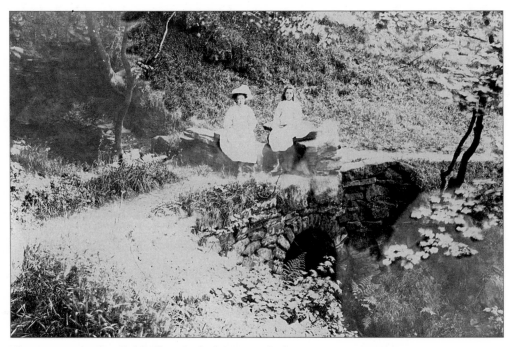

This view was simply called 'Milking Bridge' in my mother's notes.

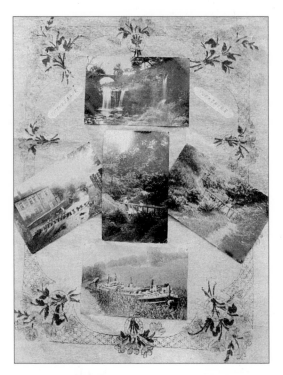

This 'vignette' of W.H. Pickard's views of the West Riding was probably composed and printed by one of his daughters.

BRITAIN IN OLD PHOTOGRAPHS

To order any of these titles please telephone our distributor, Littlehampton Book Services on 01903 721596
For a catalogue of these and our other titles please ring Regina Schinner on 01453 731114